神州畫壇

中国书画代表性名家

伍海成
吴佰如

卷

中国书店

图书在版编目（ＣＩＰ）数据

神州画坛．吴佰如、伍海成卷／吴佰如，伍海成绘．
北京：中国书店，2009.9
　ISBN 978-7-80663-729-6

Ⅰ．神… Ⅱ．①吴…②伍… Ⅲ．中国画－作品集－中国－
现代 Ⅳ.J222.7

中国版本图书馆CIP数据核字（2009）第163682号

神州画坛·吴佰如 伍海成 卷

著　　者：吴佰如　伍海成
主　　编：张　淼
责任编辑：汤慧芸　张玉岩　辛　迪
总　策　划：张玉岩
翻　　译：Michael Ng
出　　版：中国书店
社　　址：北京市宣武区琉璃厂东街115号
邮　　编：100050
电　　话：010-63017857
经　　销：全国新华书店
印　　刷：北京奥美彩色印务有限公司
开　　本：889×1194mm　1/8
印　　张：5.25
版　　次：2009年9月第1版　2009年9月第1次印刷
书　　号：ISBN 978-7-80663-729-6
定　　价：80.00元

目录 contents

中国书画代表性名家

PAINTING CIRCLE

CHINESE PAINTING AND CALLIGRAPHY REPRESENTATIVE CELEBRITIES

China

吴佰如近照

吴佰如简介

　　祖籍广东顺德。青年时随著名雕塑家潘鹤先生学习素描，打下扎实的造型基础；又师从岭南书法名家李曲斋先生习书法，得其神髓；及后又得陆俨少、吴山明老先生指授，理路大通，并融汇多家技法，用长舍短，逐渐形成鲜明的个人面目和风格。

　　自1987年至2009年，先后在世界各地举办四十多次个人画展，备受好评，作品为社会各界收藏。近年来与著名雕塑家潘鹤先生分别在佛山石景宜文化艺术馆、香港大会堂底座展览大厅、中国美院美术馆、广州艺术博物院举办四次巡回展。

　　1993年移居美国，现任美国三藩市国际艺术家协会会长。广东海外联伦会理事、中国中央书画艺术研究院艺委会委员。

Introduction to Wu Bairu

　　a native of Shunde District, learned sketch from famous sculptor Mr. Pan He and laid a solid foundation for modeling when he was young; later, he studied calligraphy from Lingnan calligrapher Mr. Li Quzhai and acquired the spirit of his work. Later, he obtained the instruction from Mr. Lu Yanshao and Mr. Wu Shanming, so he got an insight, integrated a number of techniques, complemented each other, and gradually formed a distinctive feature and style for himself.

　　From 1987 to 2006, he held over 30 individual exhibitions all over the world and had been highly commended and collected by many collectors. In recent years, he held four mobile exhibitions together with famous sculptor Mr. Pan He in Foshan Shi Jingyi Culture and Art Museum, Base Exhibition Hall of Hong Kong City Hall, Art Gallery of China Academy of Art, and Guangzhou Art Museum Exhibition.

　　In 1993, he immigrated to the United States and now serves as the president of San Francisco International Artists Association. Guangdong Oversea Sodality Council Committee Member of Art Committee for China Painting and Calligraphy Art Acadamy

中西同构写意象

——吴佰如中国美术学院画展有感　　文/郑竹三

笔墨大成意象之，岭南情韵浙江丝。
中西踪迹时代传，写得人文真善时。

　　与吴佰如先生相识于1996年的美国旧金山我的个展之中。因为艺术的相通以至心灵的交结使我们一见如故。不仅如是，佰如画意的禅境与禅象及其精神文脉简直与我同韵。这是百年之大缘与时代之必然。由是我知佰如的画道、懂佰如的艺术、解佰如的文翰，他的画是嵌在西体中用的艺术之道上，是墨韵笔情的写景之气象，是沁人心脾的人文造像，亦是艺术并文史的一维美术融合体。

　　"西体中用"是吾观佰如之画造型生动、结构科学、写实自然，只是"西体"的艺术大器，当然这亦是岭南派写真、写实、写生的美术要素，佰如实践之、掌握之、熟巧之。另则他能以书入画、以线造像、以笔传情加之墨韵的生发、墨沈的象化、墨气的情笃，使"西体"的画艺中有着东方画道的意象、有着中国画的笔墨传承、有着华夏民族的艺术本体，如是便有着如今的西体中用的美术样式。

　　"写景气象"是指佰如先生的画，还是纳入以形写神的美学之道，应该说世界万物的一切形是艺术造像的蓝本，是艺术家传神写照的造化之质，又是文化画家寓形写神、传达作者性灵、境界、文化、心胸乃至技巧的一个真善本体，故而形的万象是神艺的源流、是神象的载体、是创真的美质，除此以外的创造均是无根之木、无源之流。佰如先生生在广东，其艺术源自岭南派，而入手便是写生。其形质外师而造化，岂非妙哉。况且其画道是一维寓形而传神的笔墨造像，是一元形神兼备的创造思维，是一气中西同构的意象唯象。

　　"人文造像"乃是指佰如先生所写、所画、所图、所象均是中国人喜闻乐见的艺术形象，其画且是"禀阴阳而动静，体万物以成形，达性通变，其常不主"(虞世南《笔髓》句)的一种中国传统文人画的"假笔转心"与"澄心运思"(虞世南)成文化的人文图识。这种人文造像当然胜过西方的形质之图和构成形式，而中国人"古之成大事业、大学问者，必经过三种之境界：'昨夜西风凋碧树，独上高楼，望尽天涯路'。此第一境也。'衣带渐宽终不悔，为伊消得人憔悴'，此第二境也。'众里寻他千百度，蓦然回首，那人却在灯火阑珊处'，此第三境也。'(王国维《人间词话》）笃吴佰如众多佳作，从整体形象与造像并造化来说已渐进至"蓦然回首，那人却在灯火阑珊处"的艺术境界。妙哉，这乃是中国美术中人文造像的必经之路与必由之路也。

　　"文史融合"是吴佰如先生绘画艺术的一种文化知识与文史认识在美术图象中的一气融合。这是关乎生活积淀、关乎技巧难度等的系列文化艺术的涵碧与殊荣，为此可以想象，吴佰如付出了心智与力量，也跨越了时空并尘域，这是一个有成就艺术家的生命景风与胸襟舒怀。在他的画作之中，"文史融合"的作品颇多，如"乘风破万里浪"的达摩祖师、"天地悠悠"的陈子昂诗意、"疑是地上霜"的李白诗情、"梅妻鹤子"的林和靖、"面壁九年入禅定"的达摩、"善恶分明有济癫"以及"独钓寒江雪"的柳宗元诗境等等都是诗、文、史的艺术嘉会并在创作，此无疑是文入画创造中的一个重要课题，亦是民族文化与美术碰撞的一个永恒的传承，由此可以折射出吴佰如"文史融合"内涵的广博以及家园、国家意识的质重，这是难能可贵的，更是人物画课题中"为思想而创造形式"(前苏联　别林斯基)的一维当代美术语境。

　　旅美的吴佰如先生是幸运而自傲的，因为他转益多师、他中西同构、他文艺道合、他传承国粹…… 他在美术创作中又是清晰而自信的，因为他多元探索、他水墨笔情、他造像自然、他语境新颖、他展览交流…… 他又是一位谦谦君子，他广交良友、他兼修文德、他言行必果，他勇猛精进…… 盖吴佰如先生从艺入道乃是华夏民族时代人文之精英者也。

　　有诗为证：

君子文昌笔墨施，春秋图象国粹知。
时和岁乐年年馨，归得华夏画班师。

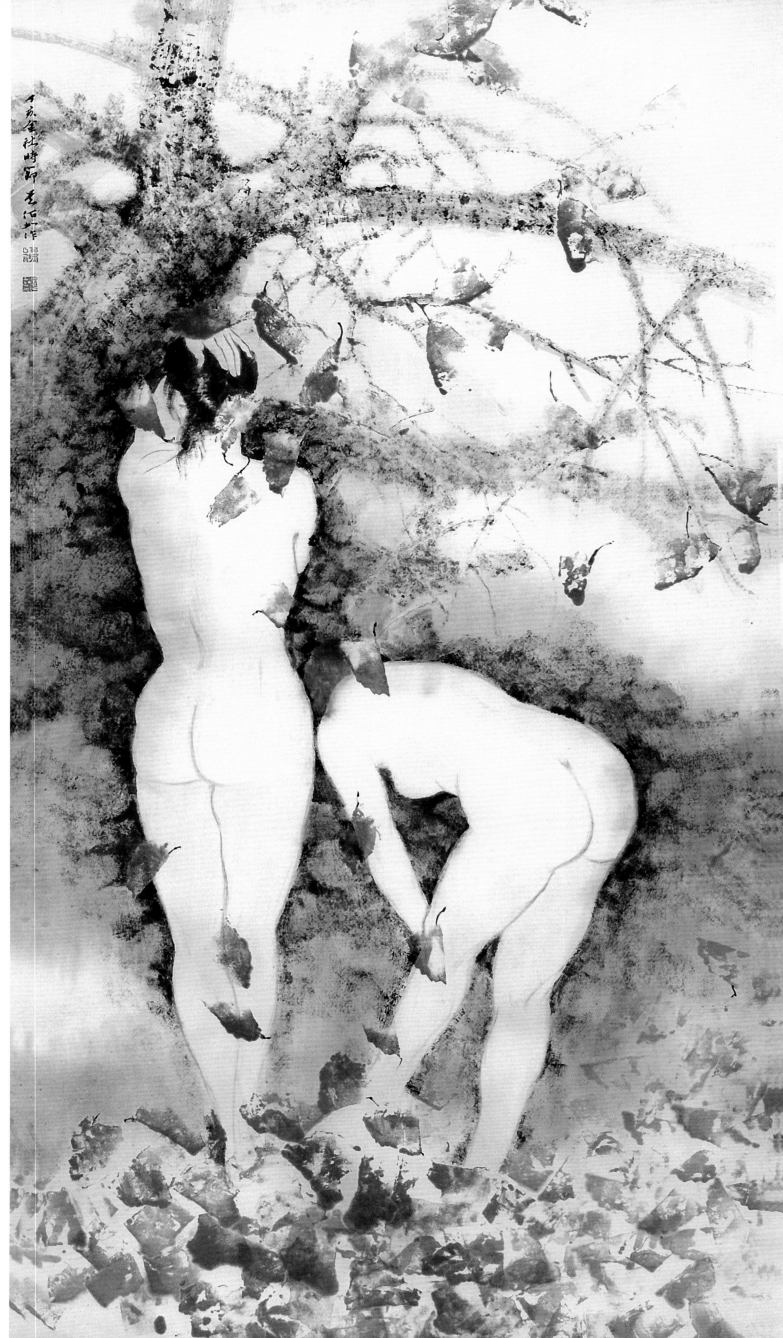

◆ 金秋　180×98cm　吴佰如作　*Golden autumn*

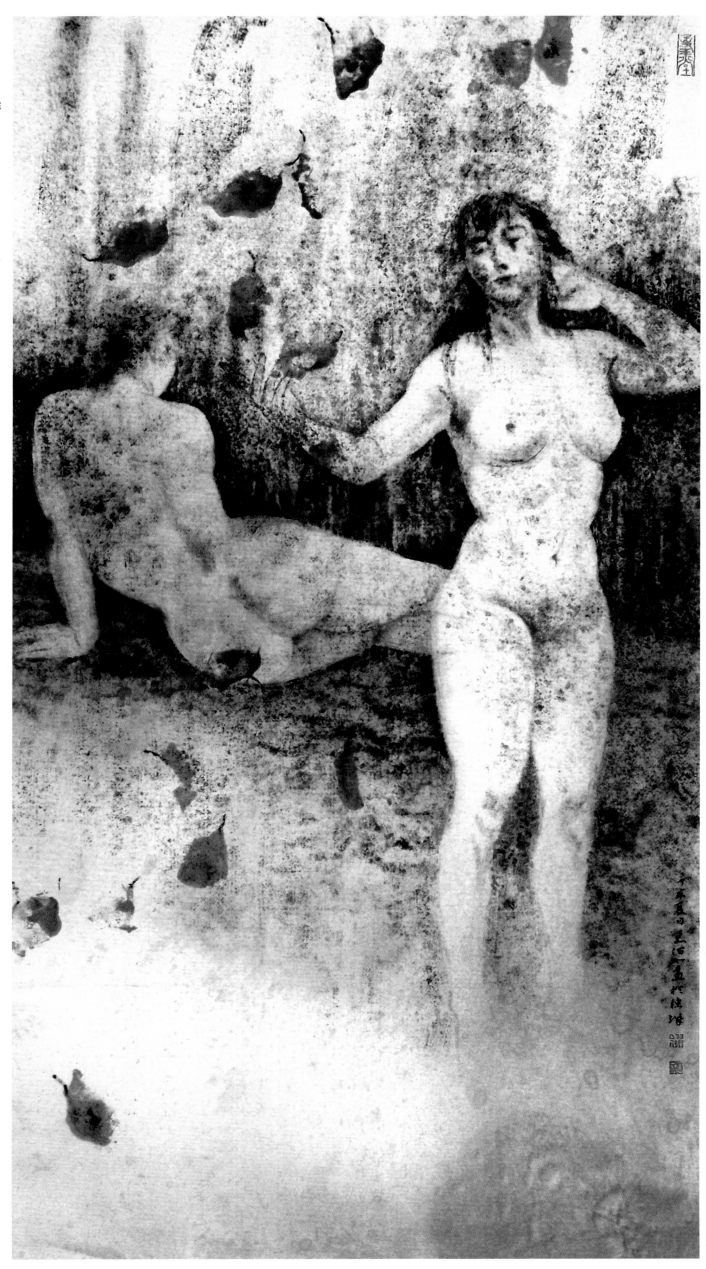

Images with Chinese and Western Methods and Ideas

——Feeling at Wu Bairu's Painting Exhibition in China Academy of Art

Write /Zheng Zhu Shan

Paintings are achieved by the images, Lingnan sentiment is the string of Zhejiang.

Chinese and western traces pass to times, the real and kind of humanism will be presented.

I met Mr. Wu Bairu during my exhibition in U.S. San Francisco in 1996. We were connected like old friends from the start with our common language of art. What's more, zen state, zen image as well as spiritual context in Bairu's paintings were provided with the same verve as mine. This is inevitable for karma and times in hundreds of years. Therefore, I know Bairu's picture track, understand his art, and catch his meaning. Bairu's paintings are embedded in art which the western system combined with traditional Chinese methods and ideas. His paintings are the description of landscape by emotional ink and brush, the refreshing humanistic statues, and also the artistic combination of art and literary history.

The "western system combined with Chinese methods and ideas" in Bairu's paintings, I find, is presented as vivid style, scientific structure and natural realism, but these are artistic achievements of "western system", of course, there are the art elements of true, realistic, sketchy painting from Lingnan School, so Bairu practices them, commands them and masters them. In addition, he could put calligraphic techniques into painting, take lines to build statues, and use brush to express emotion, together with conveyance from ink flows, changing imagery from ink sinkage, and deep passion from "ink odor", so that "western system" arts have eastern painted images, Chinese ink painting heritage, and Chinese nation's artistic body. So, there is current art style with "western system combined with Chinese methods and ideas".

"Landscape description" refers to Mr. Bairu's paintings, which have been concluded as the aesthetic way of "spirit on images". It should be said that, the images of all things are the chief source of art form, the creations for artists' vivid portrayal, the real and reliable body for cultural painters to put spirit on images, express their soul, world, culture, mind and even skills; therefore, every image is the headstream of spiritual art, the carrier of mythical images, and the beautiful matter of creation and reality; otherwise, other creations water without a source and trees without roots. Mr. Bairu was born in Guangdong, his art came from Lingnan School, and he started with sketch. He formed the quality and his teachers gave instruction, so wonderful! Moreover, his paintings are writing statue with spirit

◆ 夏荷　180×98cm　吴佰如作　*Summer lotus*

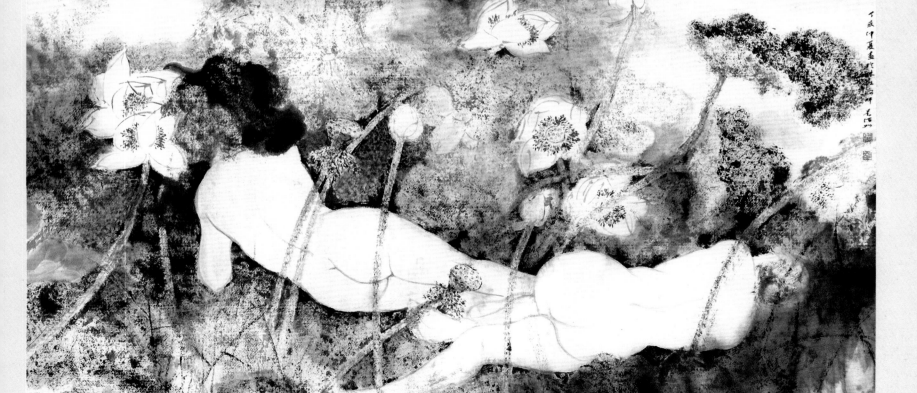

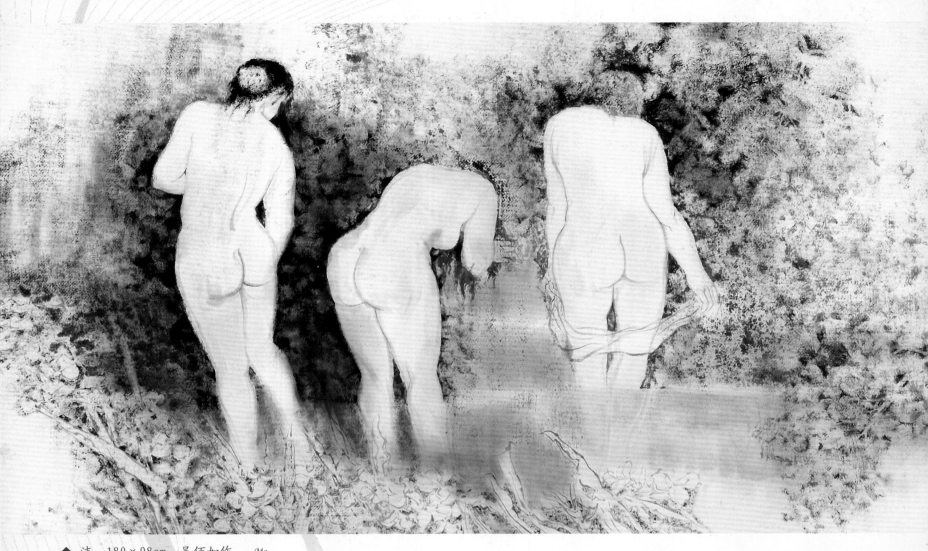

◆ 沫　180×98cm　吴佰如作　*Mo*

◆ 杨慎诗　180×98cm　吴佰如作　*Yang shen peom*

on images, creative thinking with appearance and spirit, images with Chinese and Western methods and ideas.

"Humanistic figures" refer to the artistic images that Mr. Bairu describes, draws, paints and shapes are all welcomed by Chinese people. His paintings are the humanistic pictures that "expressing feeling by brush" and "using fixed attention and deep thought" (Yu Shinan) of traditional Chinese literati paintings, whereas the traditional Chinese literati paintings have been described as "depending on yin-yang to carry out movement, experiencing and observing the world to shape images, understanding the changes of emotion and nature, there is no immovable system all along." These humanistic figures naturally exceed the form quality and structure of westerners, whereas the Chinese who make great achievements and have rich knowledge in the ancient must pass through three kinds of levels: The first level, "Westerly winds withered trees up last night. Climbing up the stairs and being lonely on the loft, I overlooked the endless distance." The second level, "The dress takes to loosen gradually and I am more and more emaciated, No regretful plying at all, I am rather for her only distressed as I did." The third level, "I've spent a lifetime searching for her. When, all of a sudden, I turned about and found her right behind waiting in the dim light. (Wang Guowei "The Poetic Remarks of the Human world") From overall image and figures, the numerous works of Wu Bairu have been gradually reached the artistic level that "When, all of a sudden, I turned about and found her right behind waiting in the dim light". That's wonderful; this is the only way that Chinese art humanistic figures must pass through.

"Integration of literature and history" is a combination of cultural knowledge and history understanding in art images. This is related to life accumulation, skill difficulties and other series of artistic content and honors. For that, we could imagine that Wu Bairu has given out great mental strength and also spanned through the time and space. This is a successful artist's life attitude and mind. Among his paintings, the works with "integration of literature and history" are many, such as: The Master Bodhidharma who "rides the wind and breaks the waves", the poem from Chen Zi'ang "heaven and earth, without limit, without end", Li Bai's poem "I suspect it to be hoary frost on the floor", Lin Hejing's "to take plum trees as wife and cranes for children", Bodhidharma who faced the wall for nine years and entered zen", "good and evil clearly demarcated by Ji Dian" and Liu Zongyuan's poetic world "cold river and fishing lonely", etc; there are all the combination and creation of poems, culture and history, so this is not only an important subject in the creation of melting culture into paintings, but also an eternal heritage of collision between national culture and art. Therefore, it could be reflected that wide connotation of Wu Bairu's "integration of literature and history", worshipful homeland and national consciousness, and even a contemporary art context in the subject of portraits "for ideas to create the form" (the Soviet Union • Belinsky).

Mr. Wu Bairu who immigrated to the United States is lucky and prideful, as he obtains skills from many masters, he paints with Chinese and Western methods and ideas, he combines literary and artistic ways, and he inherits national quintessence, etc. He is legible and self-confident in art creation, because he carries out diversified exploration with emotional ink and brush. His statues are natural and his contexts are novel; he holds exhibitions to exchange. He is a modest and self-disciplined man. He likes making friends, he focuses on both knowledge and virtue, he keeps his promises and takes resolute actions, and he exerts himself bravely and vigorously. From artistic life of Mr. Wu Bairu, we can see that he is Chinese nation's elite for humanities in this era.

Honored man lift brush in Wenchang, and presents the quintessence of a country.
Happy hours and years pass, China's painter groups return.

◆ 活佛济公　180×98cm　吴佰如作　*Living Buddha Jigong*

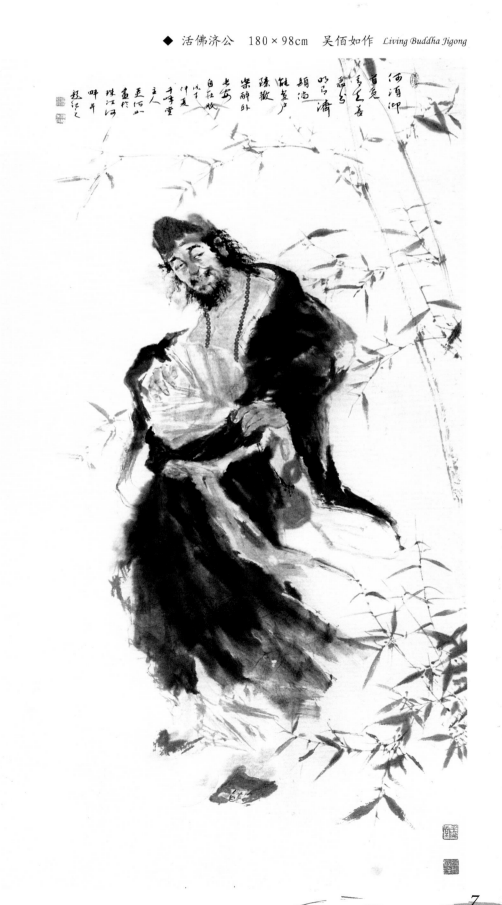

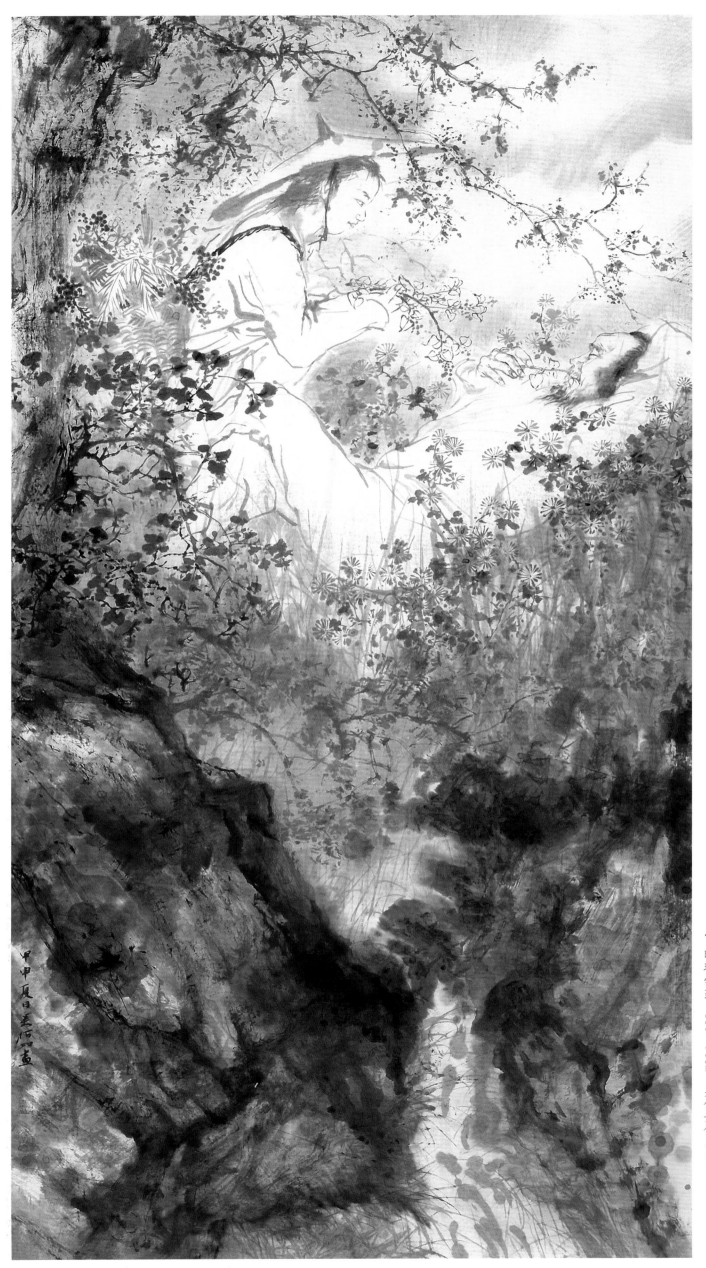

◆ 时珍尝药　180×98cm　吴佩如作　Shizhen tastes herbal medicines

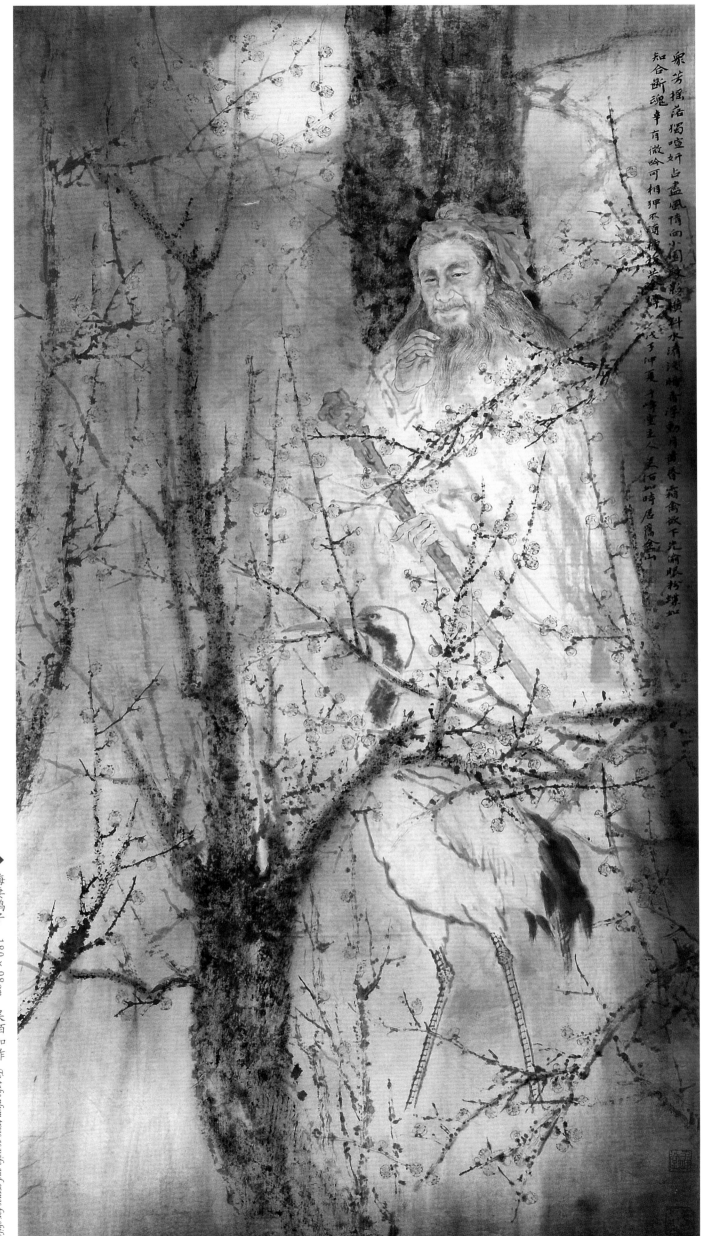

众芳摇落独喧妍 占尽风情向小园 疏影横斜水清浅 暗香浮动月黄昏 霜禽欲下先偷眼 粉蝶如知合断魂 幸有微吟可相狎 不须檀板共金樽

戊子仲夏子亭画主人 吴佰如时居隅金山

◆ 梅妻鹤子 180 × 98cm 吴佰如作

To take plum trees as wife and cranes for children

9

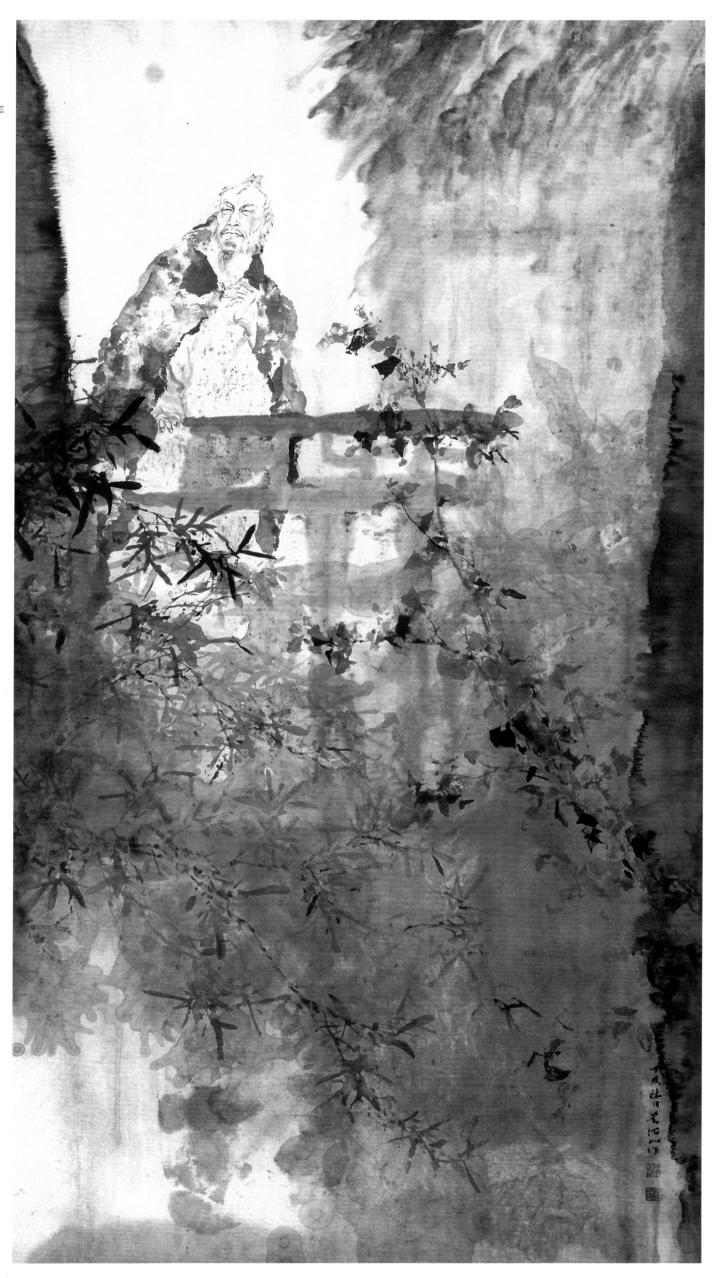

◆ 杜甫造像　180×98cm　吴佰如作　*Du Fu statue*

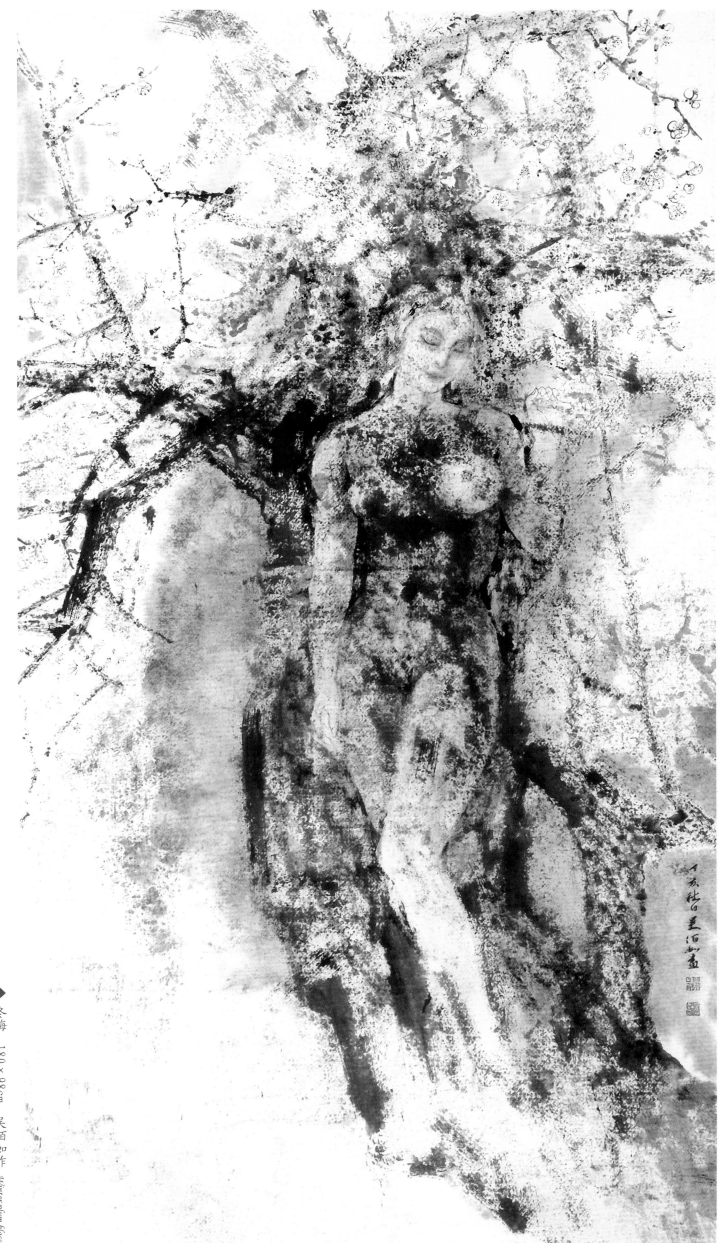

◆ 冬梅　180×98cm　吴佰如作　*Winter plum blossom*

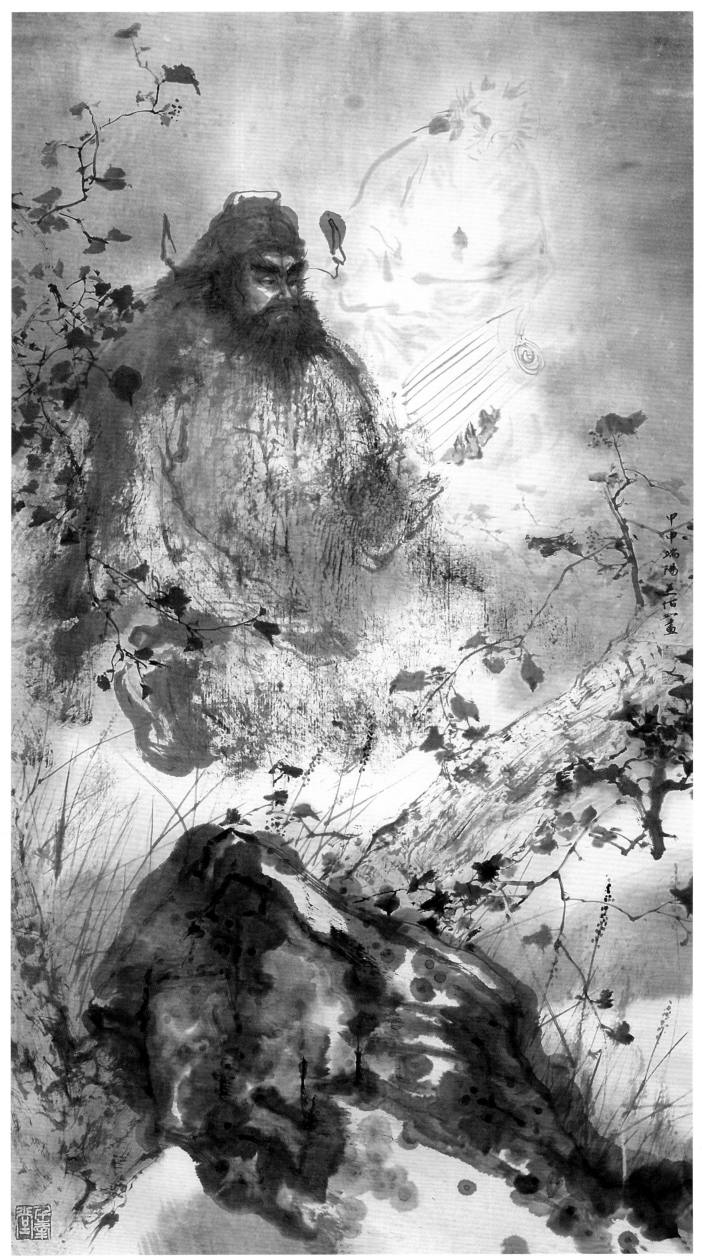

◆ 钟馗夜读　180×98cm　吴佰如作　Zhong kui stays late at night for reading

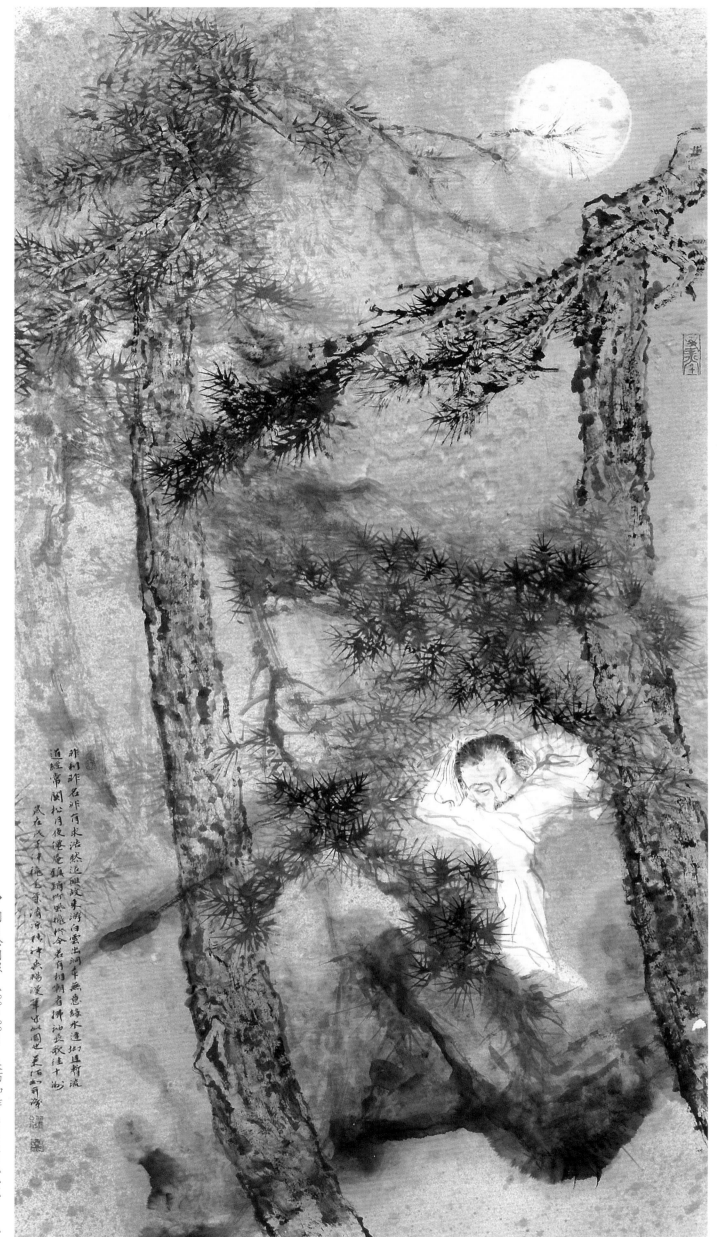

非利非名在非有求浩然追避改東游白雲出岫平無意緣水連坳遇薪流道經帝闕松月使徑匽鎮駟阿跛驢伶今若有相期者拂袖長歌注十洲

歲在戊寅年仲春录清束陳沖興陽诗筆中山圖也 吳佰如

◆ 明月松间照　180×98cm　吳佰如作

Among pines the bright moon glows

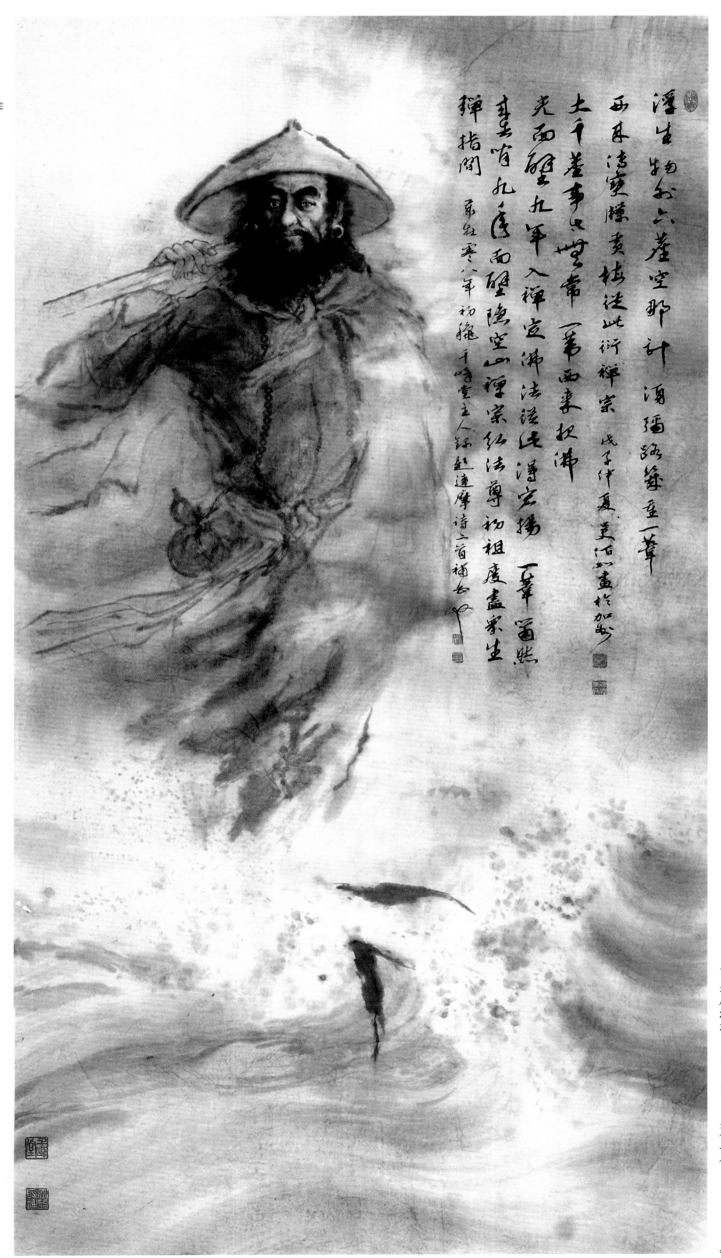

◆ 达摩渡江　180×98cm　吴佰如作　*Bodhidharma crossing*

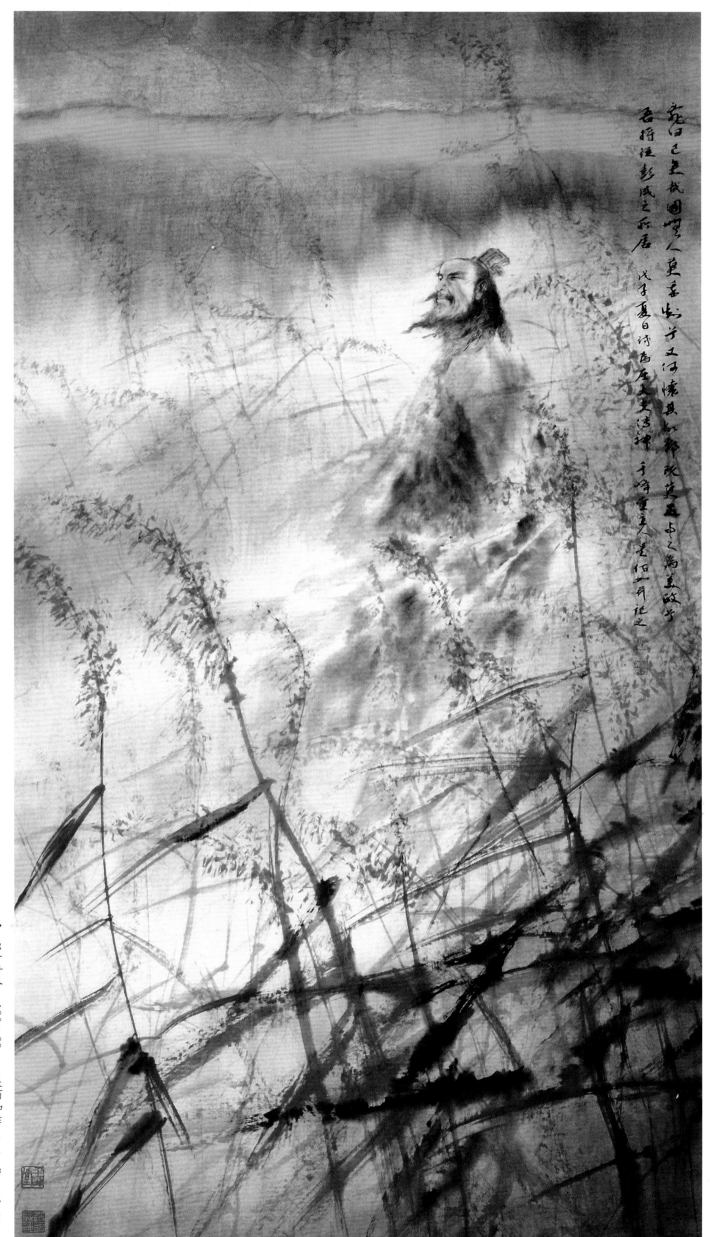

屈子行吟　180×98cm　吴佰如作　Quzi walking and reciting poems

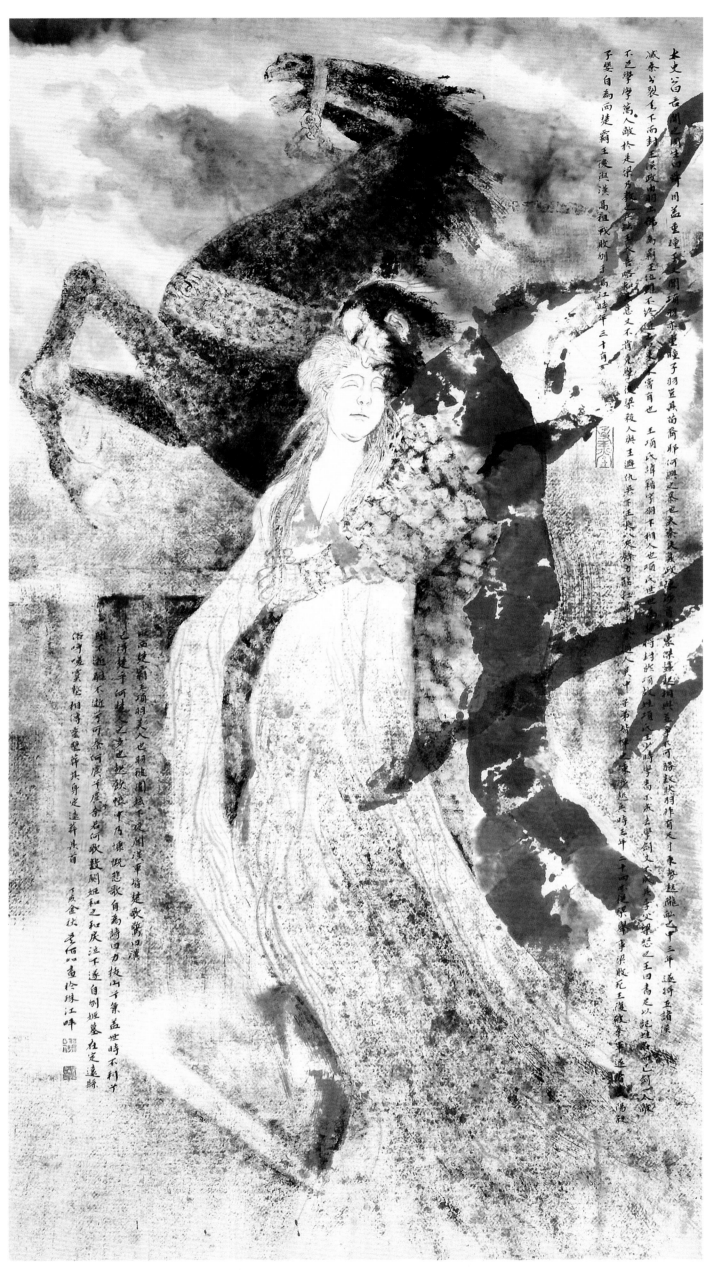

◆ 霸王别姬　180×98cm　吴佰如作

Farewell to my concubine

得道狂君不坐禅 游乡祝佛

心非恒将

府破

郁府

邪法

踪人人犀

墨辞颓

人春社千峰堂主人王佰如画於珠江河畔

◆ 能颠就颠 180×98cm 吴佰如作 *Crazy as much as you like*

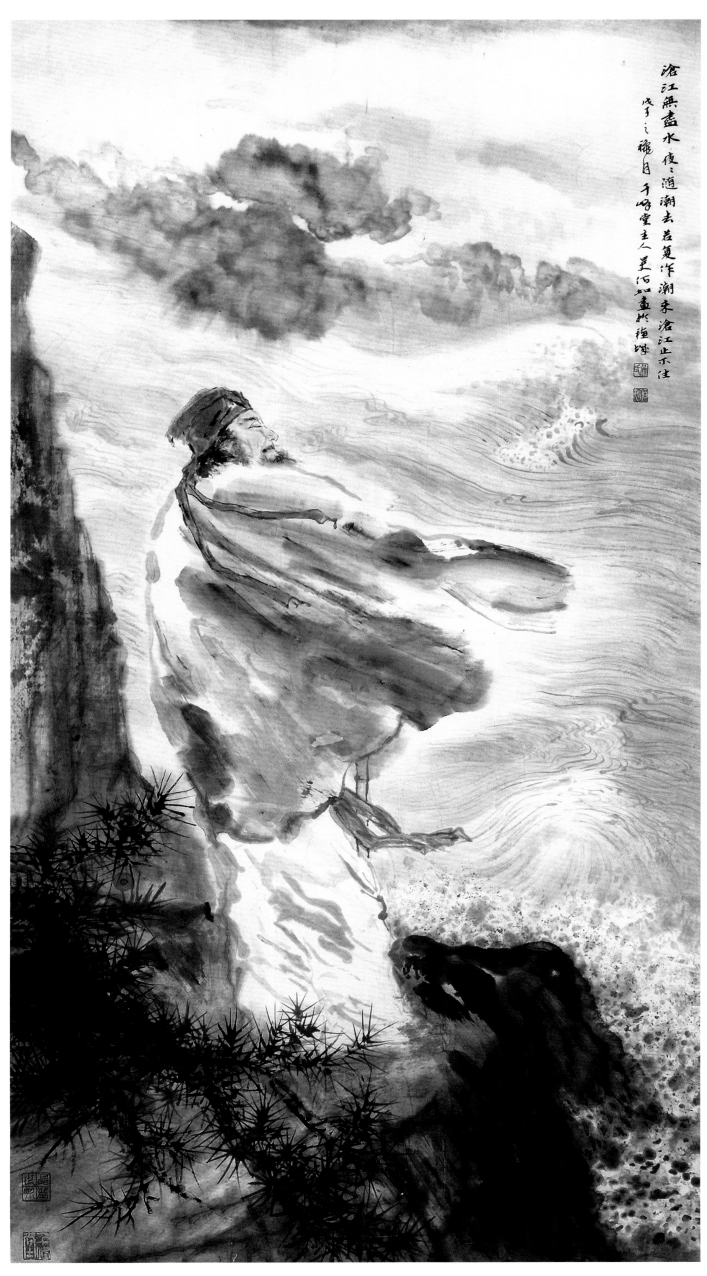

沧江無盡水夜。随潮去若復作潮来沧江止不住

戊子之穫月于峰堂主人吴佰如畫并種辭

◆ 大江东去　180×98cm　吴佰如作　*Great water flowing east*

吴
佰
如

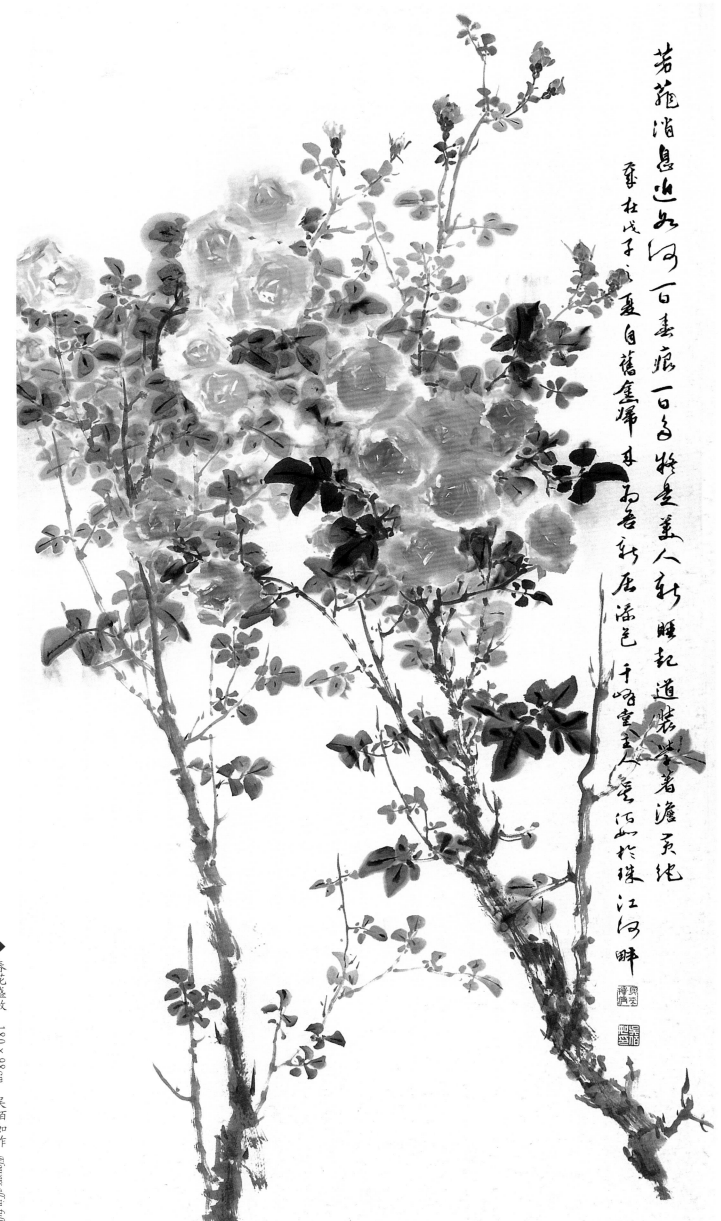

若菲浩瀚如海 百畫垂痕 百畫情恨

辛未於戊子之夏自舊金山歸來吾新居染色千峰堂主人雲淞山於珠江河畔

特是美人新睡起 道紫學著淺天地

伍海成简介

1946年生于广东顺德。1966年开始自学山水画。作品多次入选全国性及省的美展并获奖。作品先后被各级政府、部门选送到法国、日本、美国、马来西亚、摩洛哥等国家。作品也在港、澳、台和大陆的美术馆、山东、辽宁、新疆、宁夏、湖南等地展出或陈列；大量作品被《美术》、《书与画》、《画廊》、《国画家》、《中国书画》和《人民日报》、《羊城晚报》等四十余种报刊推介和省市电台、电视台专题报导，出版过《伍海成画选》、《伍海成中国画作品集》等六本画册。

从事教学四十年，1982年在顺德首先把版画教学和版画创作引进中学美术教学，并指导学生创作了各类版画一千多件。大批学生作品在国际、全国少儿画展入选、获奖。近四十件学生作品被国家和省选送到十余个国家展出并入选省成人美展。二十多年利用业余时间义务为高等美术院校培养了二百多位合格的学生，实现了顺德美术教育的三个"零"的突破。故1994年先后被评为广东省劳动模范、中学特级教师，享受国家特殊津贴。

曾任广东省中小学美术书法教研会副会长，佛山地区（市）中小学美术书法教研会理事长，佛山地区中小学美术乡土教材副主编，佛山市第八、九、十、十一届人大代表，顺德市（区）第十二届人大常委会委员；民进广东省委委员、民进顺德市（区）委会副主委。

现为中国美术教研会会员、广东省美术家协会会员、佛山美术家协会常务理事、顺德美协副主席、广东省书法家协会会员、顺德晚晴书画会会长。

Introduction to Wu Haicheng

He was born in Shunde Guangdong in 1946 and started to teach landscape painting by himself. His works have been selected and awarded in national and provincial art exhibitions for many times. Moreover, his works was successively chosen by all levels of government and departments and sent to the France, Japan, the United States, Malaysia and Morocco. Also, his works are exhibited in places like Hong Kong, Macao, Taiwan as well as domestic art museums in Shandong, Liaoning, Xinjiang, Hunan and other places; a large number of works have been recommended by over 40 newspapers and periodicals, such as: "Fine Arts", "Calligraphy and Painting", "Gallery", "Traditional Chinese Painters", "Chinese Painting and Calligraphy", "People's Daily", "Yangcheng Evening News", etc; the provincial and municipal radio and TV stations have made special coverage for a lot of works. Moreover, he published six albums of painting, such as: "Wu Haicheng Paintings", "Wu Haicheng's Collection of Chinese Paintings", etc.

He engaged in teaching for forty years and firstly introduced print teaching and print creation in the art teaching of secondary school in Shunde in 1982. Moreover, he guided the students to create more than 1000 pieces of prints; the works from a large number of students were selected and awarded in the international and national children's painting exhibition. Nearly 40 students' works were sent to over 10 countries for exhibition and selected into the provincial adult art exhibitions. Wu Haicheng dedicated his spare time for over two decades to cultivating more than 200 qualified students of art colleges and universities, which realized three "zero" breakthrough of Shunde art education. Therefore, in 1994, he was successfully awarded as model worker of Guangdong Province and the teacher of special grade of secondary school, and he enjoys the state's special allowance.

Wu Haicheng served as vice president of Guangdong Primary and Secondary School Art and Calligraphy Teaching Research Institute, president of Foshan Primary and Secondary School Art and Calligraphy Teaching Research Institute, associate editor of Foshan Primary and Secondary School Fine Art Regional Teaching Materials, deputy to eighth, ninth, tenth, and eleventh People's Congress of Foshan, member of the NPC Standing Committee of Shunde, member of Guangdong Provincial Committee of China Association Promoting Democracy, and vice chairman of Shunde of China Association Promoting Democracy.

Wu Haicheng now serves as the member of China Art Teaching Research Association, member of Guangdong Artists Association, standing director of Foshan Artists Association, vice president of Shunde Artists Association, member of Guangdong Calligraphers Association and president of Shunde Wanqing Calligraphy and Painting Association.

精骛八极 心游万仞

——画家伍海成 文/陈坚樵

"外师造化，中得心源。"是中国画创作经典理论的精粹。它将主体与客体同置于互动的辩证之中，体验中和的美学理想。对于造化，中国画家着重的，往往是精神层面上的对自然的感悟。南朝的宗炳，卧游千里，并不在意于某名山、某大川，只存了操琴"欲令众山皆响"的期许。古代名家所作的山水，标题虽为某山某水图，并无实景可资对照。这并非中国人的写生能力出了什么问题，而是理念与表达方式的独特与超然所致。中国山水画家常说："真山真水在心中"，或说："胸中自有百万丘壑。"这，大概就是感悟自然有了得着的那种情怀，已进入可以自由挥洒笔墨的良好状态。

山水画，先从写生来，一笔一笔老老实实地对景摹写，忠实于对象的构成与关系；再而，移情入物，澄怀味象；再三，是不断地感悟山水精神；最后，可以进入心游万仞、物我两忘的境界，握有写山水即写我心的神奇功力。这是一个漫长的、无休止的修炼过程，需要从人格的修养、学问的修养与笔墨的修养上下苦功，决非单靠技法训练所能达到。画家伍海成先生浸淫山水画创作逾四十年，作品以数千计，在中学培养、输送学生进入美术院校学习达二百多人，深知为学的甘苦。经常勉励学生，老老实实做人、老老实实做学问，不背弃传统、不离弃生活。他首先是一个忠诚的教师，把教书育人放在首位，然后，他才是一位杰出的、经历了上述四种阶段磨炼的、卓有成就的山水画家，同时他也是一位谦和、诚实、友善的、热爱生活的画家。

海成近年从教师岗位退休了，旋即在画坛上异常活跃，推出了一个接一个写山系列的中国画展览：黄姚山水系列、太行山系列、黄山系列、三清山系列……令人目不暇给。我不讶异他一批比一批画作之多、之快、之精，因为他是一个非常勤快执着的人，学养深、技法娴熟、出手快。我十分赞赏他那些新作的"系列"，确是真山水的风貌，各不含糊，并无气味仿佛。三清山就是三清山，不会与太行的作品相类。这是因为，海成对山水那种敏锐的感觉、倾情的审视与即兴的对景创作，确有过人之处。一些非常精通画理画法的画家，尚且往往使山水画陷入程式化、概念化之中，此山彼山一个样，中国外国的景致亦无二致，笔墨的图式化与刻板，无法满足有地域地质特征的、有独特个性的、不同气质的乃至不同植被于阴晦晴明、四时变幻的意境的表现。这是因为，这些所谓画家确实欠缺了面对真山真水的真挚的了解与对话，心中无数。海成之所以能举重若轻，挥运之际纵横捭阖、得心应手，其中，笔墨的承载，是不可忽视的重要因素。他花过极大的气力、漫长的时间，向传统学习，黄卷青灯、风雨鸡鸣、十日一水、五日一石，退笔成山地研究临摹过多少古人范本；又复研究了宋元明清不同流派之法；也不避嫌从当代大家、可为我用的技法中汲纳营养，正是这长久不懈的功夫涵养，使他在非一般的高度上蓄积了深厚的造型能力和丰富多姿的笔墨手段。作画时，随时能进入心手相忘的状态，真山真水已化入胸中，成为一种情意的倾诉。我见过海成相隔十年的"太行系列"山水画，差距何其的大，后十年的太行画，折带皴与小斧劈皴的流美运用，笔染墨晕的酣畅华滋，绝胜十年前之作。海成频频涉足名山胜水，一次又一次增益其对山水的亲和感悟，也见证了古人的各种皴法、水法都是从不同的地域地质的真山水中，经长期的意象沉潜提炼而成，是一种高于现实的优美符号，其他石法、树法等等也莫不如此，笔法、墨法、渲染赋彩等构成中国画的要素，皆是先贤灵觉智慧的结晶、创造。不能以过时的概念去淡化，更应以当代的精神，使之不断丰富和发展。海成最近出版过一本叫《南人北韵》的山水画集，其意不说自明。他喜欢阳刚的东西，作为秉性柔秀的南方水乡人，这是性格中大包容的体现，也有见贤思齐的内蕴。海成先生经常强调，中国画要善于利用散点透视的优势，对其他一切有用的、有参考价值的技法善于利用，不惜旧瓶装新酒，不惜借尸还魂……我无意间保存了海成早年临摹古人的几幅画作，到今日看其作品，已无复看到笔法的出处，难于指认这一笔有倪元镇的影子、这一法有石涛的遗意。几幅画黄山西海大峡谷的新作，山岩巍峨挺拔、奇松敧石而出，危危的人工栈道人小而渺，那奇松，我觉着有点弘仁的用笔，但细看又不像，这真是入了一种化境了。其实不着痕迹便是最好的。

我们不及一一细论海成先生的画，但一种感觉是强烈的，这就是他的画作人气，磊落、阳光。或许，线条既有独立的审美价值，又要服从主体需要，但它尚有无穷无尽的变化的奥妙、无限的韵致可讲究；墨渖内外，虚白与虚黑间藏有许多玄机和变幻，有无限丰富细腻的语言，像乐章中的华采，适当的时候才会妙曼地流泻，一切，都会在时间与空间的推移中臻于至善。犹记四十年前，一次闲聊，我问他今生有什么追求，他答，做一个画家！他做到了。这已够令我无限钦佩。

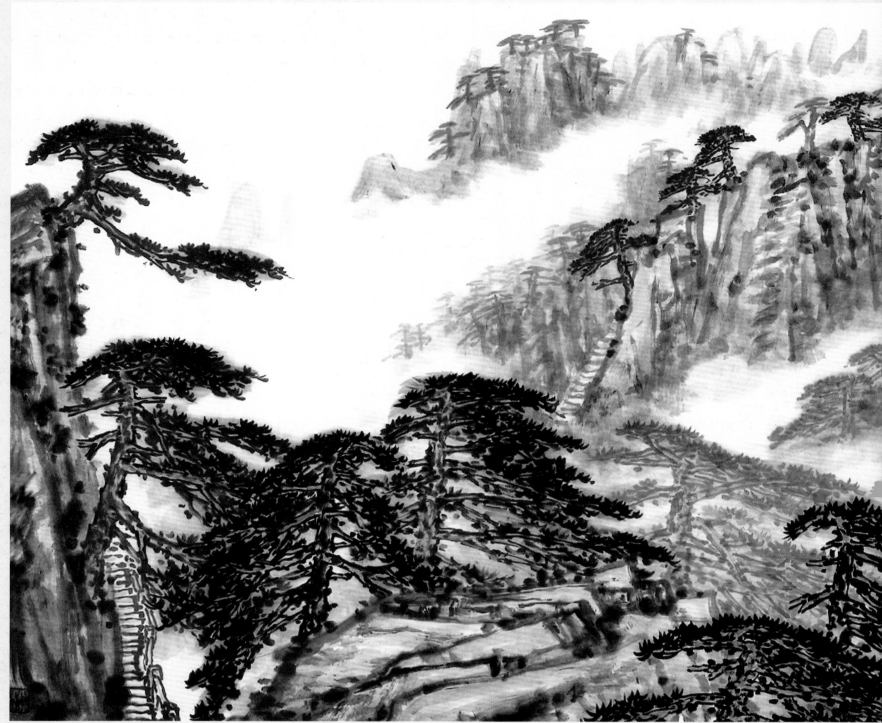

伍海成
黄山松云
Huangshan Mountain pines
180 × 90cm
2009年

Powerful Artistic Conception and Unconstrained Style

——*Artist Wu Haicheng*

Writen/ Chen Jianqiao

"Exterior creativity comes from interior accomplishment"is the essence of classical Chinese painting theory, which places the subject and object on the interactive dialectics together and experiences compromising aesthetic idea. For creation, Chinese artists focus perception of nature on spiritual level . Zongbing, in Southern Dynasty, travelled all around, but never cared about the fame of mountain or river; he only kept the expectation of "making numerous mountains echo by musical instrument". The titles for landscapes that ancient artists made are paintings for some mountains and some rivers without real scene. However, this point does not indicate Chinese people are unable to sketch, but the unique ideas and methods as well as transcendence. Chinese landscape artists often say, "the real mountains and rivers are in mind", or"the beautiful sight is in

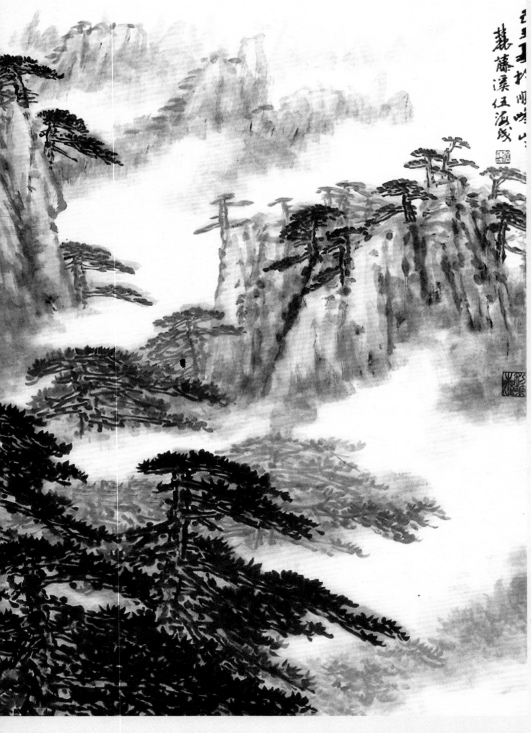

mind." Probably, this is the sentiment from nature perception, so they could draw freely as they wish.

As to the landscape painting, firstly, the sketching, the artists shall face the scene, carefully paint and observe the composition and relationship of the object; secondly, the emotion shall be moved into the outer together with sublime aesthetic taste; thirdly, the artists continuously apprehend the spirit of landscape; finally, they could enter powerful artistic conception and forget the subject and the object, which achieves the realm that painting the landscape is to describe their mind. However, this is a long and endless process of practice for the cultivation of personality, knowledge and painting but not simple technique and training. The artist, Mr. Wu Haicheng, has engaged in landscape for over four decades with thousands of works; in secondary school, he has cultivated and sent more than 200 students to enter art colleges and universities. He is deeply aware of the sweetness and bitterness of study, and often encourages the students to be an honest man and learn in earnest with no betrayal of tradition and life. First of all, he is a loyal teacher and puts "imparting knowledge and educating people" at the first place; moreover, he is an excellent and

successful landscape artist who has experience the above four stages' exercises; thirdly, he is a modest, honest and friendly artist and has a deep love for life.

In recent years, Haicheng retired from his teaching position and has been quite active in painting circle, launching Chinese painting exhibitions for mountain series one after another: There are too many exquisite paintings for the eye to take in, such as: Huangyao landscape series, Taihang Mountains series, Huangshan Mountain series, Sanqingshan Series, etc. I am not surprised at the number, speed and exquisite of his works, as he is a diligent and persistent artist with deep cultivation, skilled technique and high speed. I really appreciate his new "series", which are styles and features of real landscape, no ambiguity and no resemblance. Sanqingshan is just Sanqingshan and dissimilar to Taihang Mountains work. This is because Haicheng has outstanding capacity in the keen sense of landscape, emotional survey and impromptu creation. Some artists who are accomplished in painting theories and methods often involve in stylized and conceptual landscape, so the mountains are just the same and scenes at home and abroad are similar. The stylized and stereotyped paintings fail to meet the representation of artistic conception for regional geological features, unique personality, different temperaments and different plants under darkness or light as well as changing scenes in four seasons. This is because the so-called artists are short of sincere understanding and dialogue to the real landscape and they are unclear in mind. However, Haicheng could make all difficulties easy, maneuvers to paint with facility; painting cultivation is an important factor. He spent a great effort over a long time to learn from tradition, assiduously studied regardless of outer world, conceived exquisitely but never hurriedly painted, and imitated various models of the ancients by numerous brush pens. Moreover, he researched different schools of Song, Yuan, Ming and Qing Dynasties and absorbed nutrients from techniques all over the world. Just these unremitting

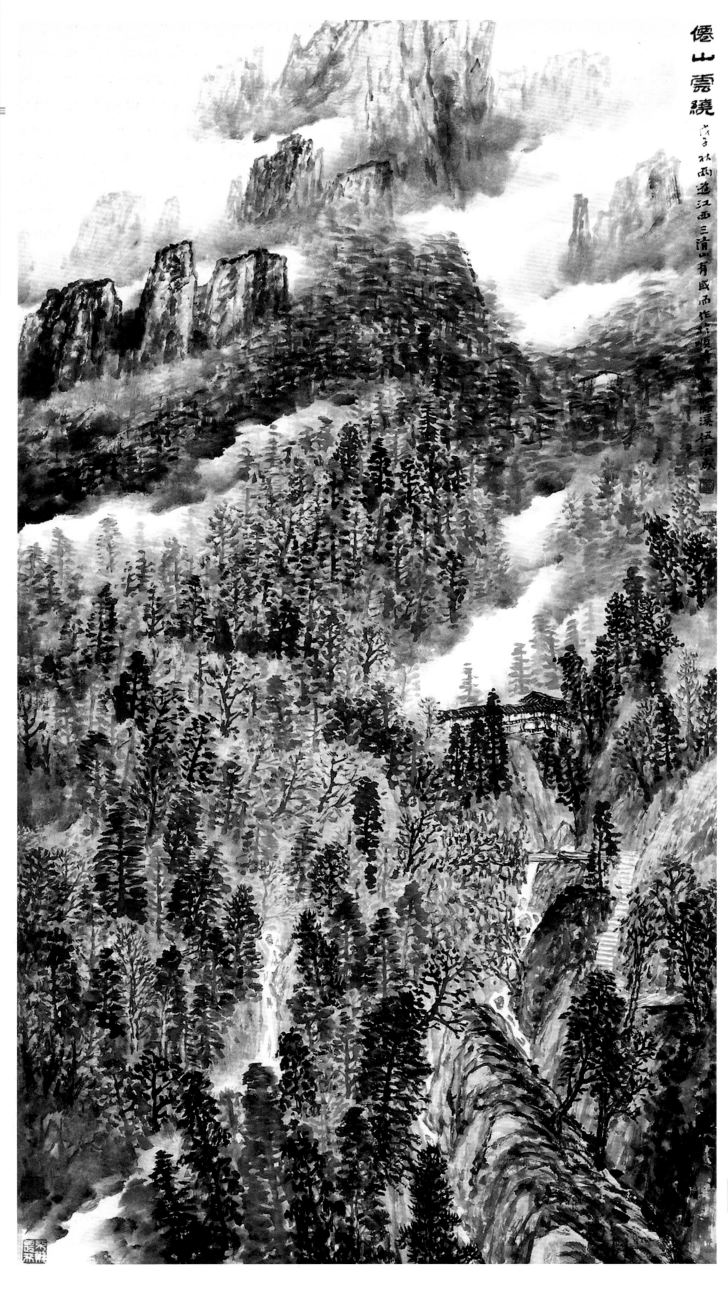

僊山靄繞

戊子秋雨過江西三清山有感而作于城南苕溪伍海成

efforts and genius achieve his profound modeling capabilities and rich experience in paintings. When painting, he could easily get into the state and melt real landscape into mind to confide the affection in the painting. I have seen the landscape paintings "Taihang Mountains Series" separated by a decade, whereas the differences are great. The Taihang Mountains paintings after decade has smooth and elegant application for band texture and small axe-chop texture, the paintings are merry and lively, which surpass the works before decade. Haicheng frequently sets foot in famous landscapes, gains his affinity and perception to them over and over, and also witnessed a variety of ancient texturing and water methods coming from different geographical landscape for a long time; they are beautiful symbol above the reality, stone, plant and other methods are just the same. Painting style, ink using, rendering and coloring are the basic elements for Chinese landscape, which are crystal and creation of the wise men and could not be diluted by out of date concept, but contemporary spirit to constantly enrich and develop. Recently, Haicheng published a landscape collection "South People North Rhyme", its meaning is quite clear. He likes masculine things; as calm and delicate southerner in watery region, it indicates not only the great inclusiveness of character, but also the implication of emulating wise and excellence men. Haicheng often emphasizes Chinese paintings shall take advantage of cavalier perspective, make full use of all useful and valuable techniques, present new concepts in an old framework and revive an outdated practice. I unintentionally kept Haicheng's several imitations at early stage; now, I appreciate his works and fail to see the derivation of painting styles, so it is difficult to point which painting has the shadow of Ni Yuanzhen and which painting has the Shi Tao's style? In several new works about Xihai grand canyon in Huangshan Mountain, the mountains are majestic, tall and straight, pines are breaking through the stones, and perilous artificial path is small and vague. The pines, I think, are the style of Hongren, but I carefully check, it is not! It really enters a transformation realm. In fact, leaving no trace behind is the best.

We will not discuss all the paintings of Hangcheng, but a feeling is strong, that is, his paintings are powerful, unconstrained and healthy. Perhaps, the line has independent aesthetic value and subordinates to the principal part. But it is still provided with endless changes and limitless charm; the ink marks, dim white and dim dark conceal numerous tricks and changes as well as limitless and exquisite language, just like tune in movement; it could pour at appropriate time and reach excellence over time and space. I remember in a chat forty years ago, I asked him what the pursuit of life? He replied, an artist! He did! This has made me admire greatly.

伍海成

太行纪游
Taihang Mountains travel
180×97cm
2007年

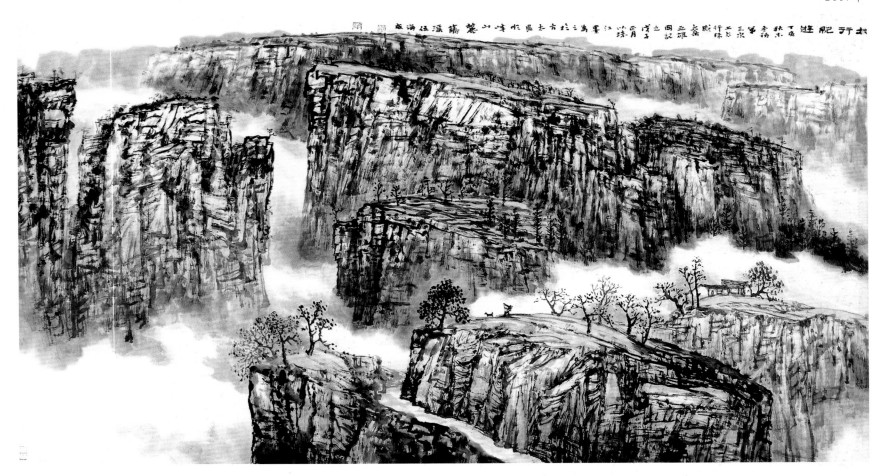

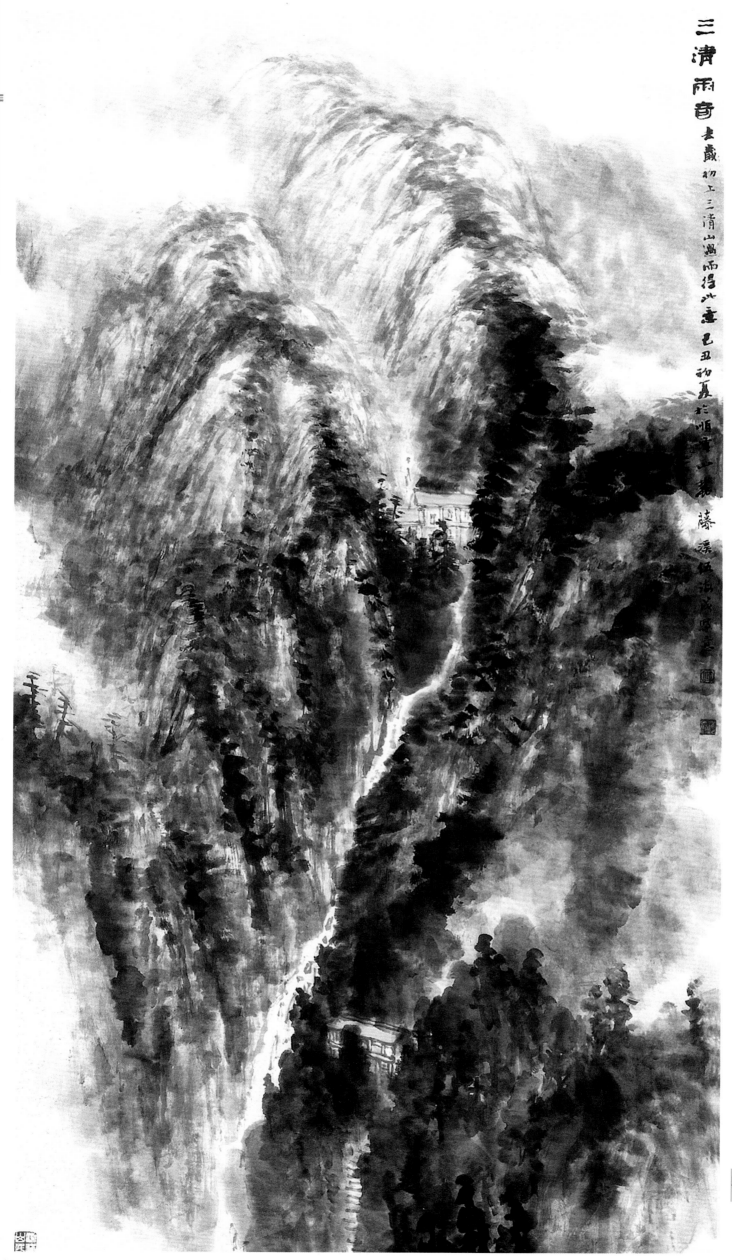

三清雨奇 去歲初上三清山遇雨得此章 己丑初夏於順德藤溪伍海成畫

伍海成
三清雨奇
Sanqingshan rain
180×97cmv
2009年

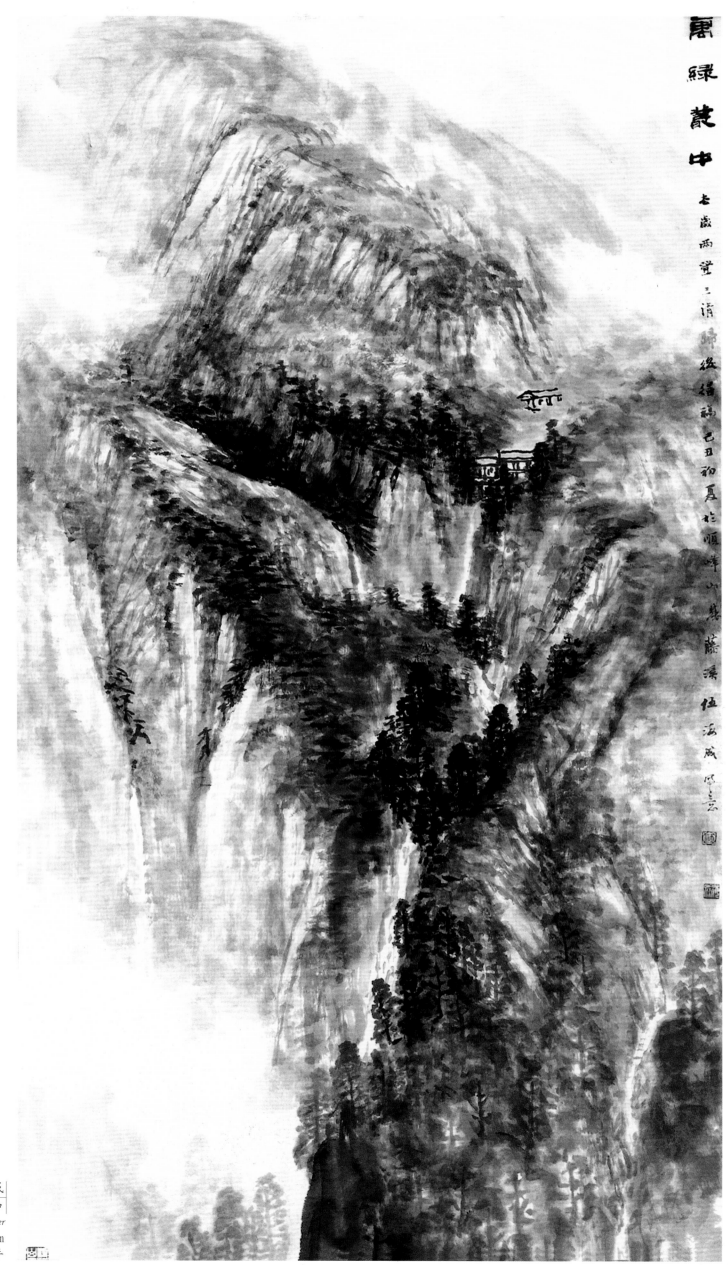

万绿丛中

太岁两登三清归途福祸己丑初夏于顺峰山装藤溪伍海成写之

伍海成
万绿丛中
Green cluster
180×97cm
2009年

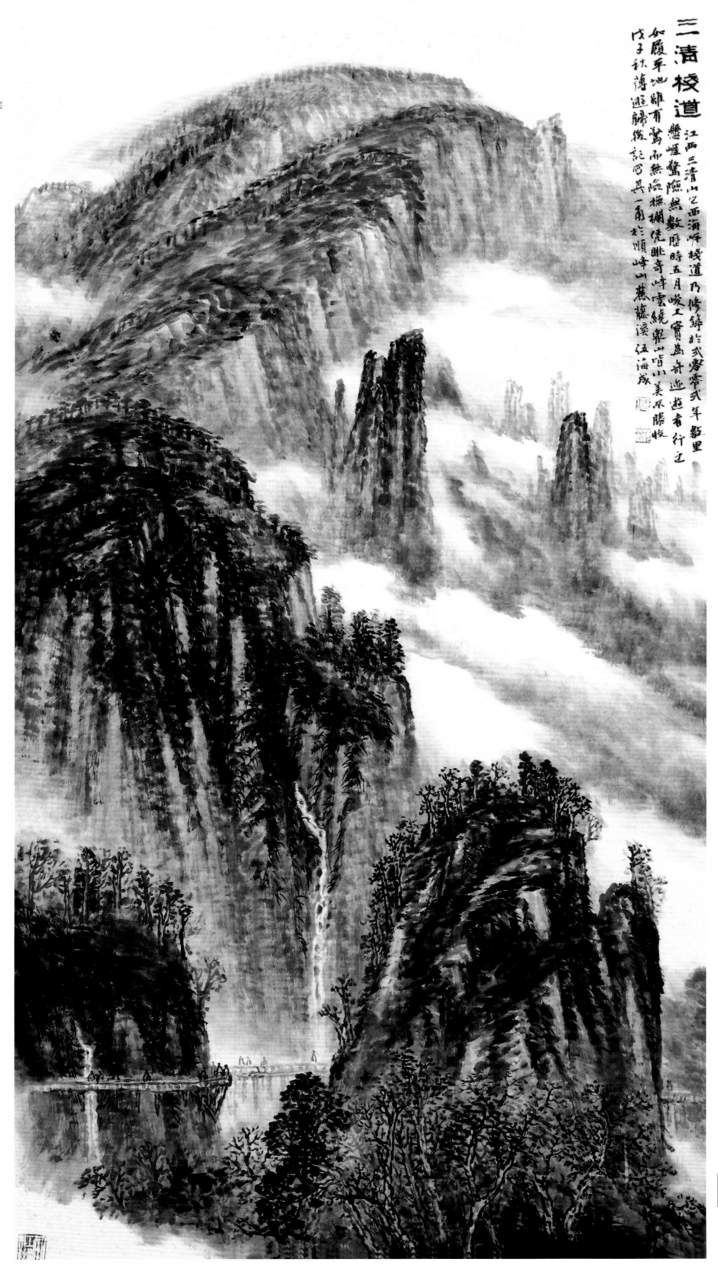

伍海成
三清栈道
Sanqingshan plank path
180 × 97cmv
2009年

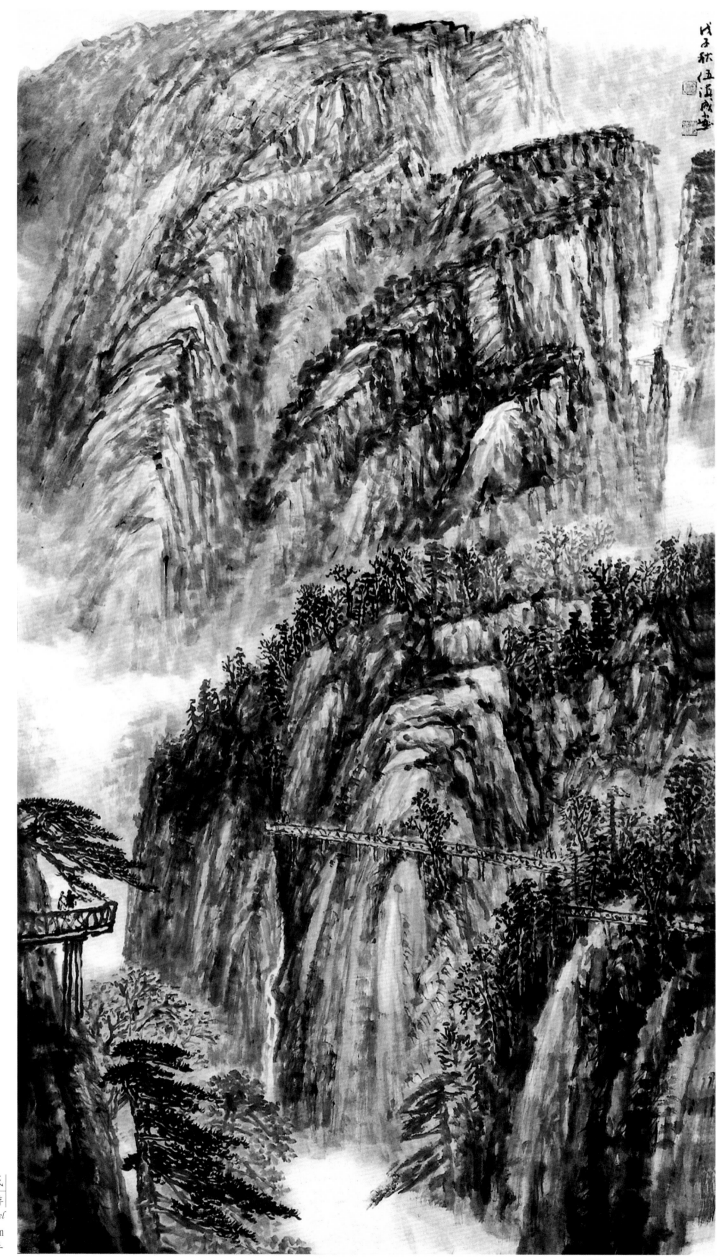

伍海成
三清纪游
Sanqingshan travel
180 × 97cm
2008年

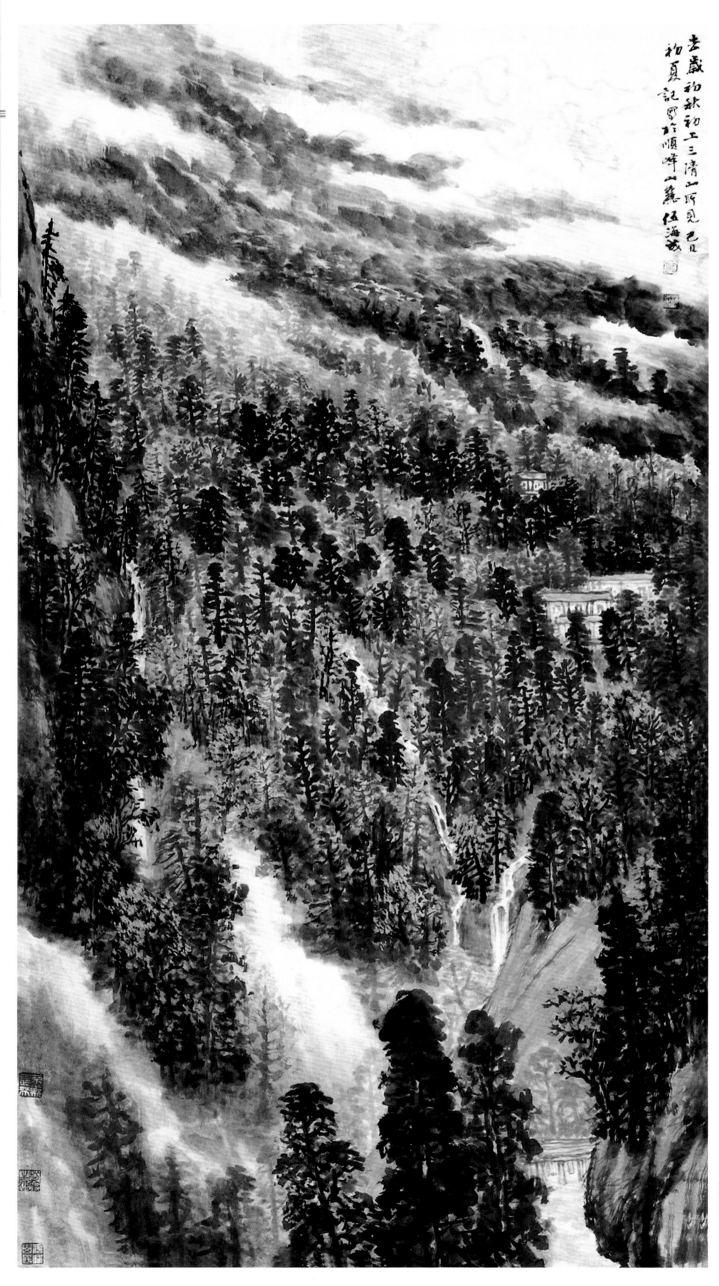

去歲初秋初工三清山所見己日
初夏記寫於順峰山麓 伍海成

伍海成
雨后山更青
Greener mountain after raining
180×97cmv
2009年

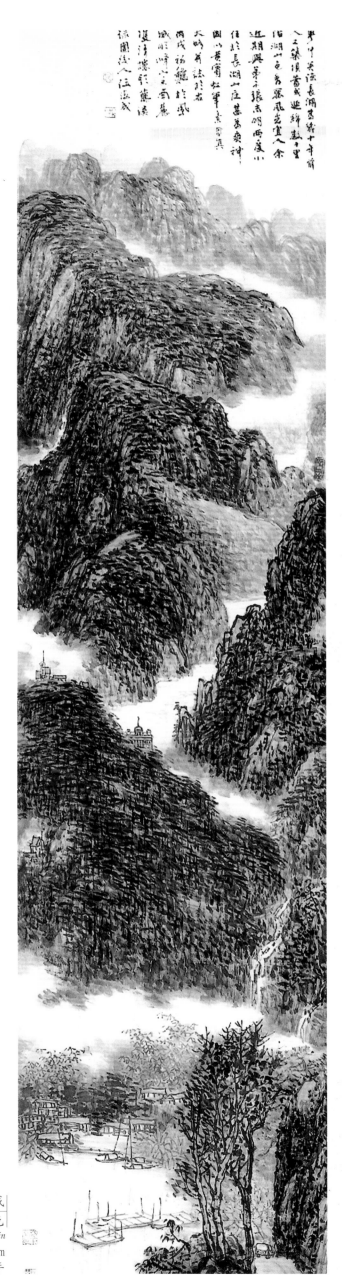

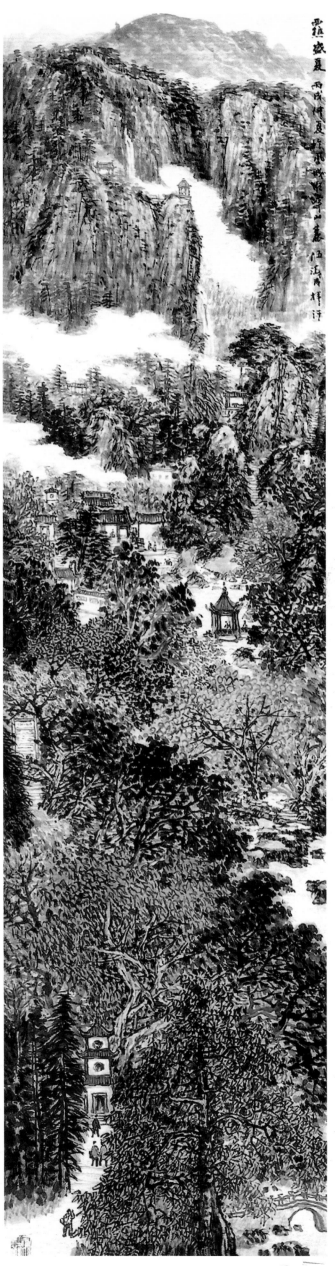

伍海成
长湖山色
Changhu mountain
235 × 55cm
2007年

伍海成
西樵夏日
Xiqiao summer
235 × 55cm
2006年

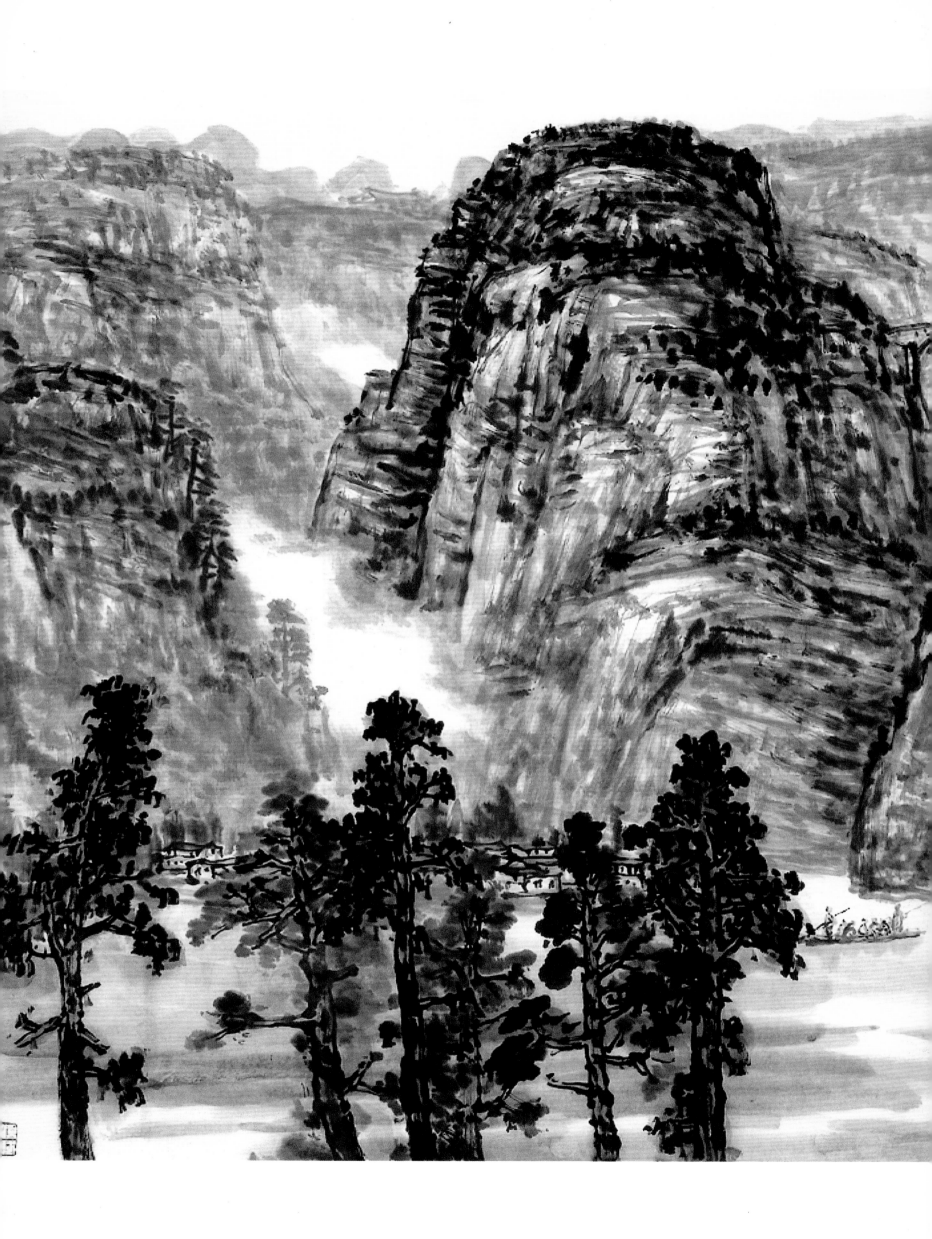

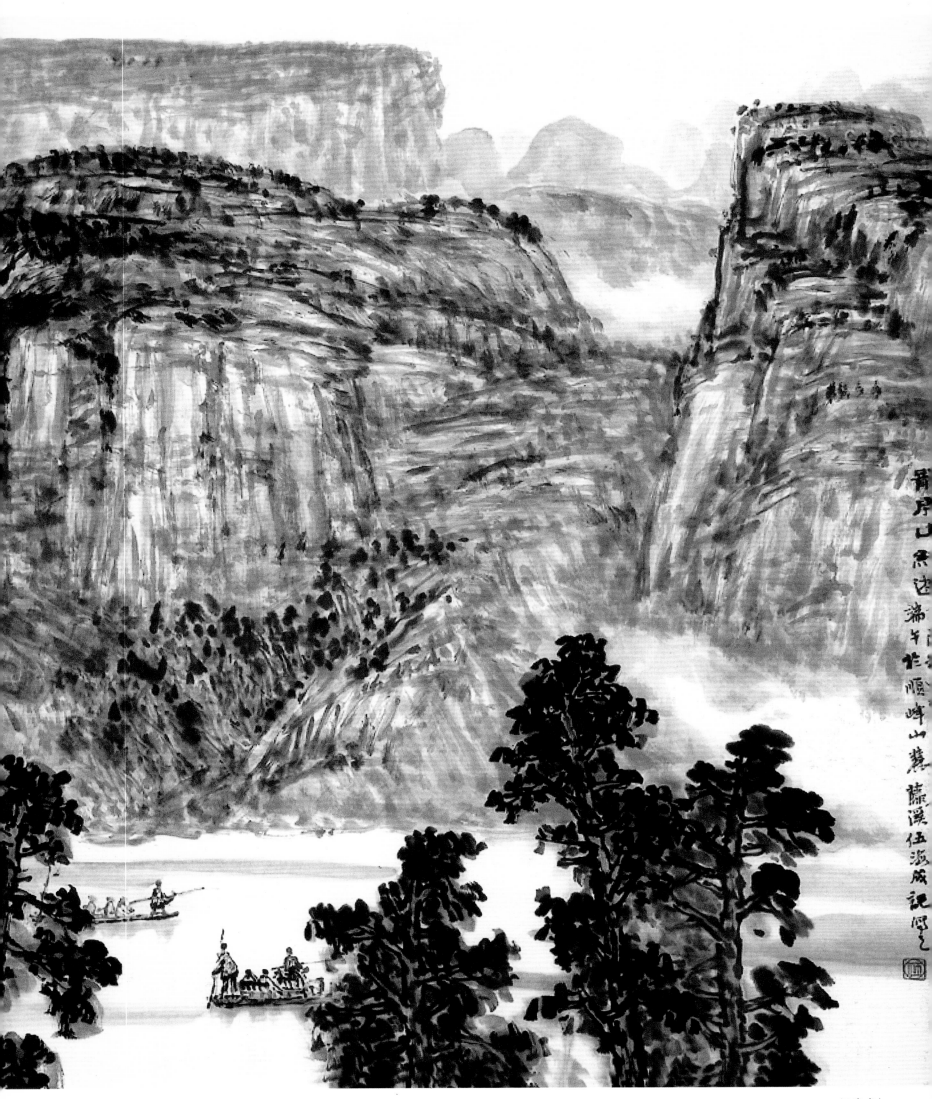

伍海成
龙虎山纪游
Longhushan travel
180×97cm
2009年

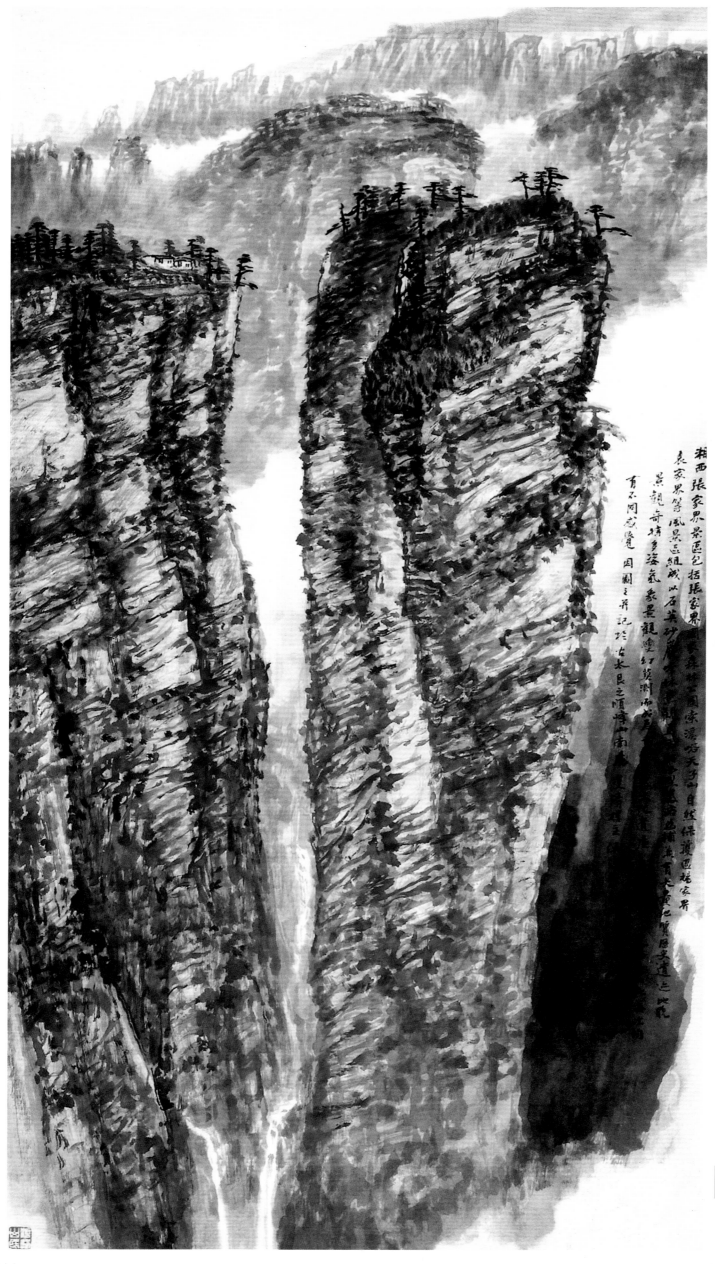

People in drawing

伍海成

人住画图中

People in drawing
180×97cm
2008年

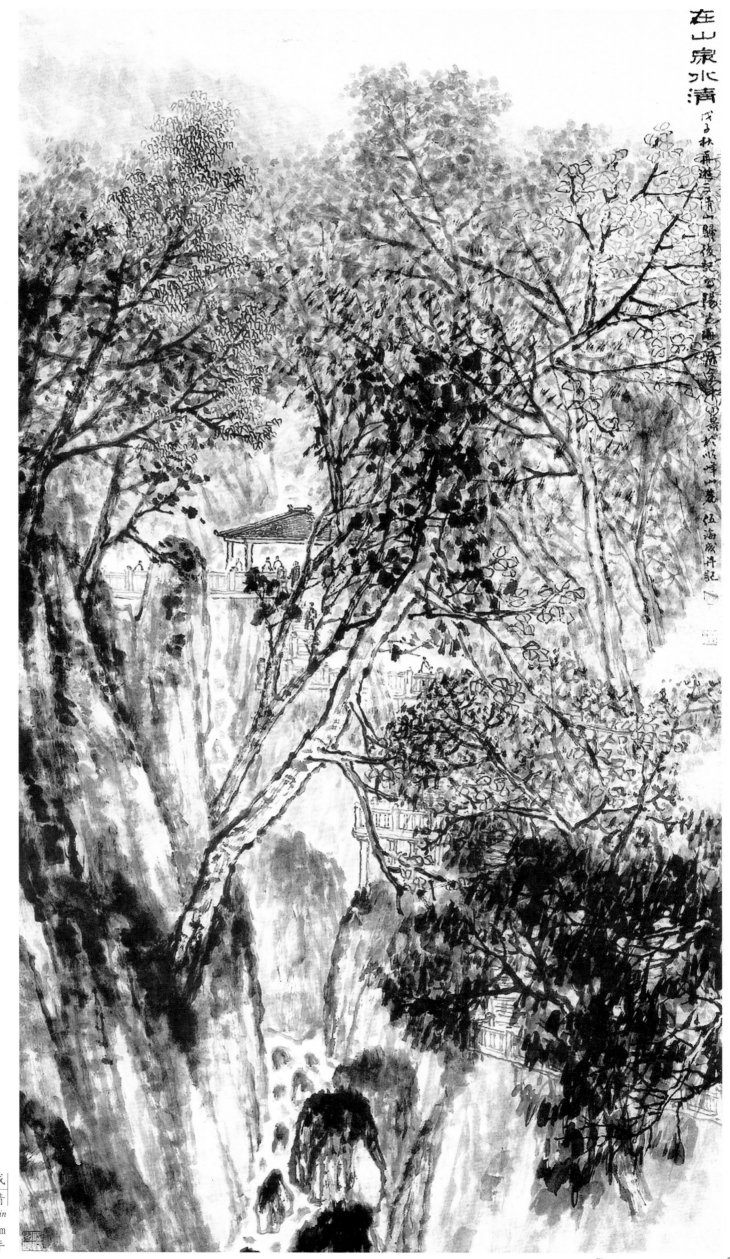

在山泉水清

戊子秋再游三清山歸後紀……陽去海……山景秋水峰山麓 伍海成弁記

伍海成
在山泉水清
Fountain is clear in mountain
180×97cm
2008年

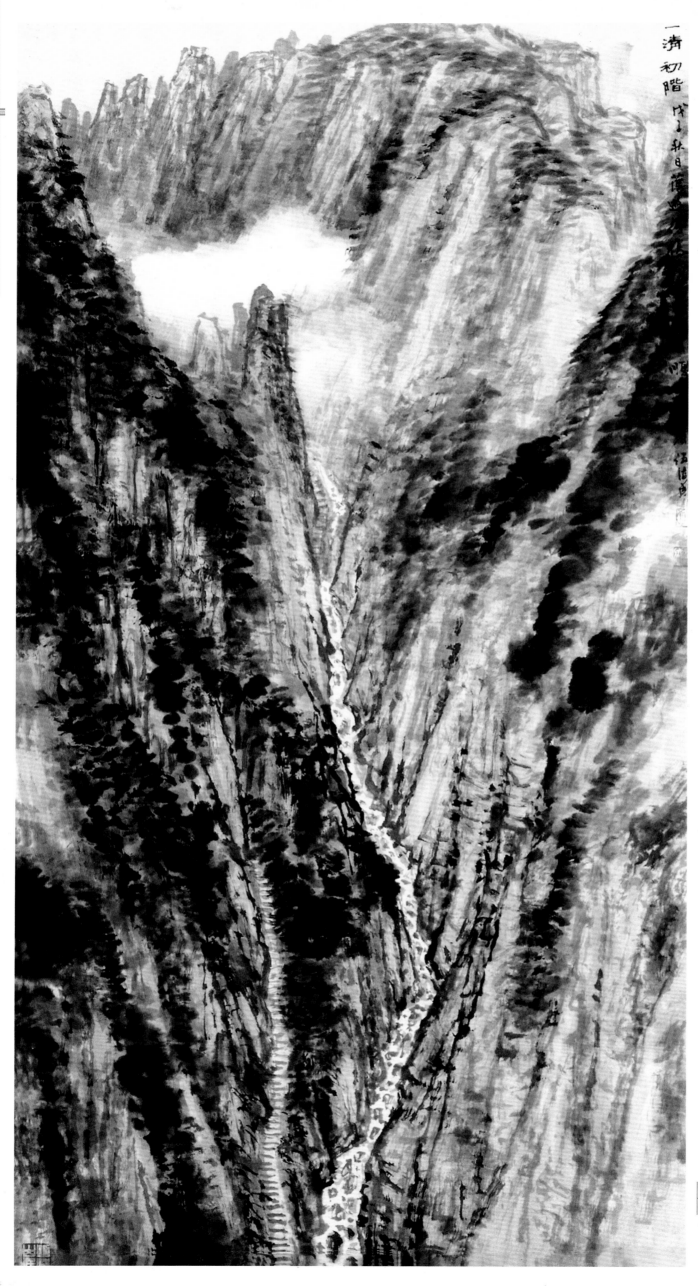

三清初阶 戊子秋日蕅初

伍海成
三清初阶
Sanqingshan Early stage
138 × 69cm
2008年

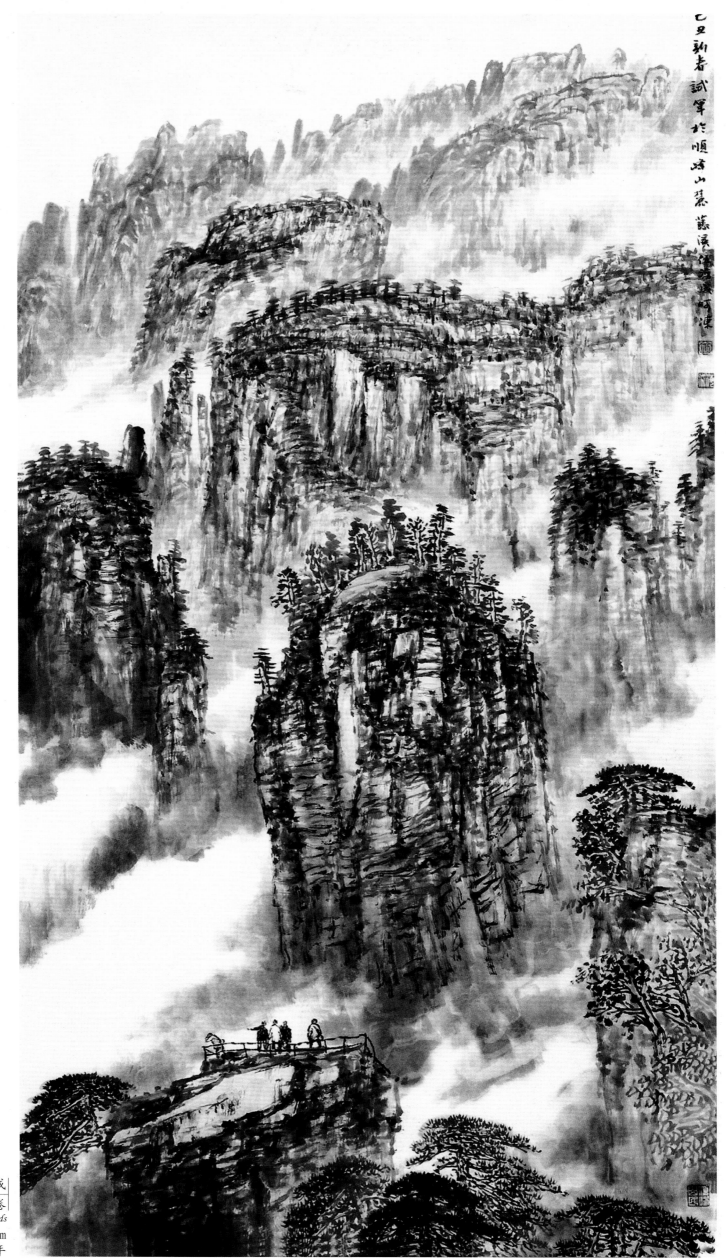

伍海成

漫看云舒云卷
Appreciating cloud rolls and spreads
180×97cm
2009年

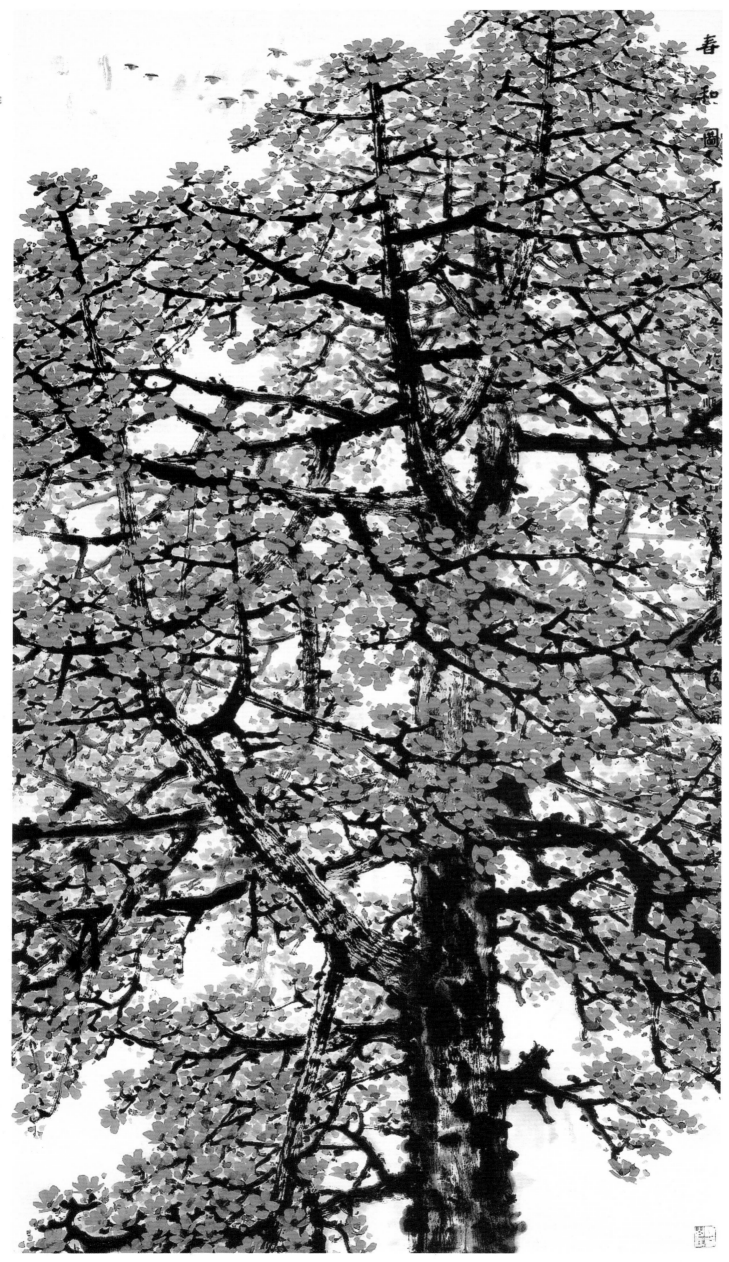

伍海成
春和图
Spring Picture
180×97cm
2007年